HOW TO DRAW MANGA
Colorful Costumes

HOW TO DRAW MANGA: Colorful Costumes
by Tadashi Ozawa

Copyright © 2000 Tadashi Ozawa
Copyright © 2000 Graphic-sha Publishing Co., Ltd.

This book was first designed and produced by Graphic-sha Publishing Co., Ltd.
in Japan in 2000. This English edition was published by Graphic-sha Publishing Co., Ltd.
in Japan in 2003.

Graphic-sha Publishing Co., Ltd.
Sansou Kudan Bldg. 4th Floor
1-14-17 Kudan-kita, Chiyoda-ku, Tokyo 102-0073 Japan

Collaborating illustrators: Yoriko Mochizuki, Chika Majima, Tadasuke Kitamura,
Toshio Kobayashi, Taisuke Honma
Original design: Kazuo Matsui (Robinsons)
Main title logo design: Hideyuki Amemura
Writer: Saho Kimura (SPOOKYS)
Planning editor: Sahoko Hyakutake (Graphic-sha Publishing Co., Ltd.)
English edition editor: Glenn Kardy (Japanime Co., Ltd.)
English edition design & layout: Reminasu
English translaion management: Língua fránca, Inc. (an3y-skmt@asahi-net.or.jp)
Foreign language edition project coordinator: Kumiko Sakamoto (Graphic-sha Publishing Co., Ltd.)

Distributed by
Japanime Co., Ltd.
2-8-102 Naka-cho, Kawaguchi-shi,
Saitama 332-0022, Japan
Phone/Fax: +81-(0)48-259-3444
E-mail: sales@japanime.com
http:// www.japanime.com

First printing: January 2003

ISBN: 4-7661-1337-3
Printed and bound in China by Everbest Printing Co., Ltd.

Colorful Costumes

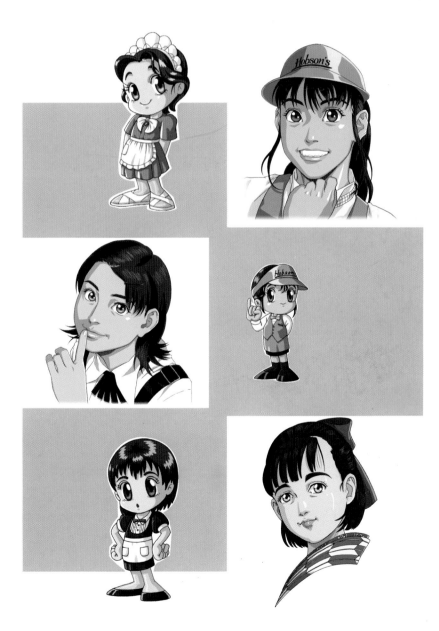

TABLE OF CONTENTS

Foreword

When I was a student, I had a crush on a girl and once stopped by the café where she worked. What I saw there was neither the girl in the school uniform nor the girl in her street clothes whom I knew so well, but rather a girl I had never seen before. My heart leaped into my mouth—I was nervous and dumbfounded.

Today, I often have the opportunity to draw girls and women in uniforms in relation to my work, but I was finding that whenever I tried to draw girls such as the one I had seen that day, something was missing. Now, I like drawing pretty, young women, mind you, and I give it my all. Yet, the sense of tension I felt when I saw the girl of my dreams that one time seemed to have disappeared. The delicate, fair arm I saw as a student now eluded me.

But why, I wondered. Why did this escape me? Perhaps it was just a question of skill. Whenever I tried to depict the girl in that café, I just couldn't seem to capture on paper the image in my mind.

After being rather perplexed about the matter, I at last realized I needed to replicate the uniform she had worn that day. What my drawings needed was not to capture her charm, but rather to depict her uniform to give her a sense of "realism."

However, none of the uniform pictorial guides I found in bookstores were of much help. Those books didn't have any pictures showing the backs of the uniforms, and the overall composition and smaller details of the garments were unclear. I began to grow frustrated over my inability to express in my own artwork that sense of pulsating excitement I felt when I saw my crush in her uniform.

To produce this book, I received help from numerous sources, and as a result was able to give the content a certain, substantial form. I would like to take this opportunity to thank the wonderful people at the various restaurants and cafés I researched for their gracious cooperation. Readers' reception of the final product will likely vary: some may view it as sentimental, others as a resource. Nevertheless, I sincerely hope that all readers will find this volume a useful reference for drawing a new and different world and for expanding their own artistic skills.

Tadashi Ozawa

Please note that all the information in this book was current as of August 2000. The information is subject to change without notice.

Restaurant Uniforms

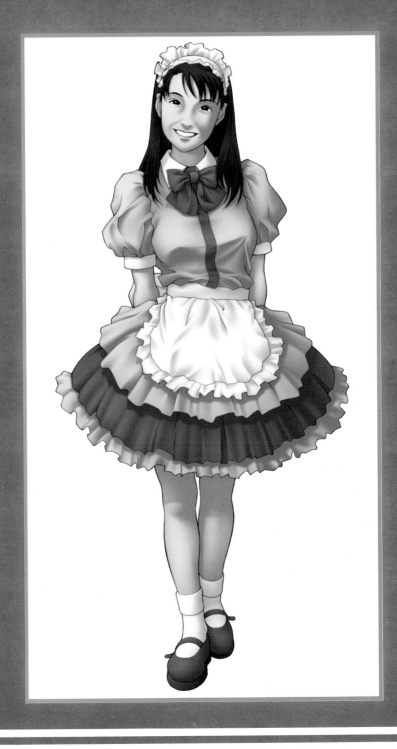

La Marée de Chaya

Café and Cake Shop

La Marée de Chaya is a chain of cake shops whose flagship restaurant is located on the waterfront near Tokyo. The franchise maintains many branches throughout the city, most of them within department stores. The staff is always friendly, and the café's atmosphere cheery. The uniform consists of the traditional white apron over a black dress; however, it is the smaller details that bring out the uniform's charm.

CHECK POINT!

My research for La Marée de Chaya was primarily conducted at one of its branches in the basement of a well-established department store. Hence, the café followed policies more characteristic of a department store than of a café. For instance, the waitresses were rather restricted in their use of cosmetics. Their hair was pulled back firmly in a linen headpiece, and the wearing of nail polish and heavy makeup was strictly prohibited.

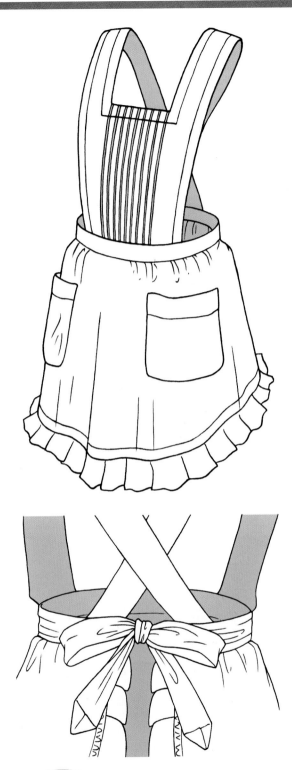

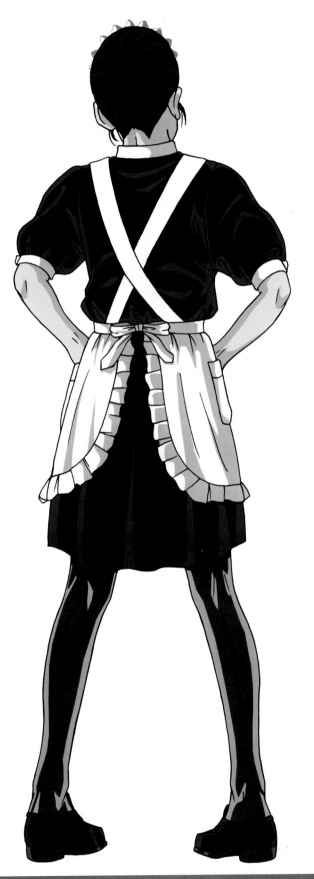

CHECK POINT!

The apron is really a pinafore bordered by large ruffles. The bib includes striped gathers. The crossover straps in the back allow for adjustment to match the size of the wearer.

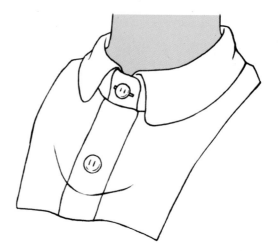

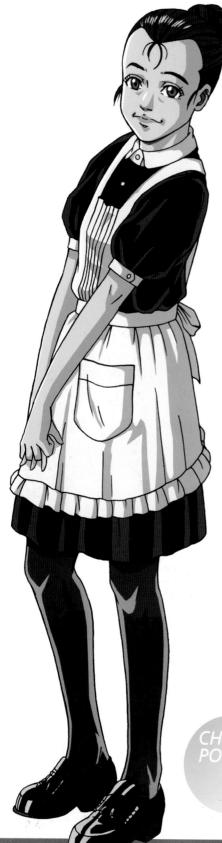

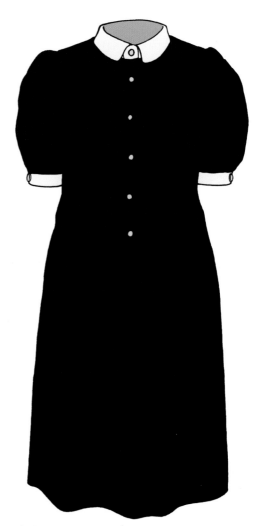

CHECK POINT!

The dress ends just above the knees and features a semi-flared skirt. The round collar is composed only of a neckband and wings. The dress's front has six buttons, but the dress is actually fastened from the back. The black stockings worn with the uniform are required under department store policy.

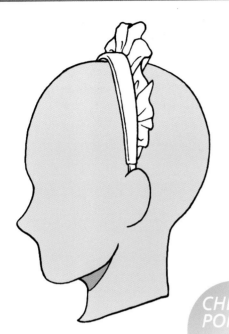

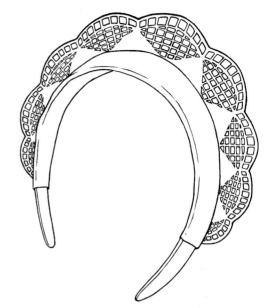

CHECK POINT!
The headpiece is worn like a headband, straight from the crest of the head to the ears. Consequently, it is placed far above the forehead. Hairpins are often used to hold the headpiece and prevent it from slipping.

CHECK POINT!
The shoes worn with this uniform are primarily black or brown loafers. The sleeves of the dress are puffed, and the button on the cuff is purely decorative. The same uniform is worn even during the winter. However, the department store's climate-control system makes the short-sleeved dress perfectly comfortable year-round.

SHOP INFORMATION!

La Marée de Chaya
This franchise features an original menu of so-good-they-melt-in-your-mouth cakes and pastries. Fresh, seasonal ingredients are used in the pastries, allowing for a constantly changing menu. As I noted earlier, the branch I used for research is located in a well-established department store, and the staff is very friendly. At the flagship restaurant, located in

Hayama, the visitor is able to enjoy a luxurious atmosphere. The waitresses even pour refills from silver coffeepots!

This café is worth a visit:
La Marée de Chaya
(Flagship Restaurant)
20-1 Horiuchi Hayama-machi,
Miura-gun, Kanagawa Prefecture
Tel.: 0468-75-5346
Hours: 10:00 a.m. to 9:00 p.m. daily

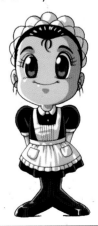

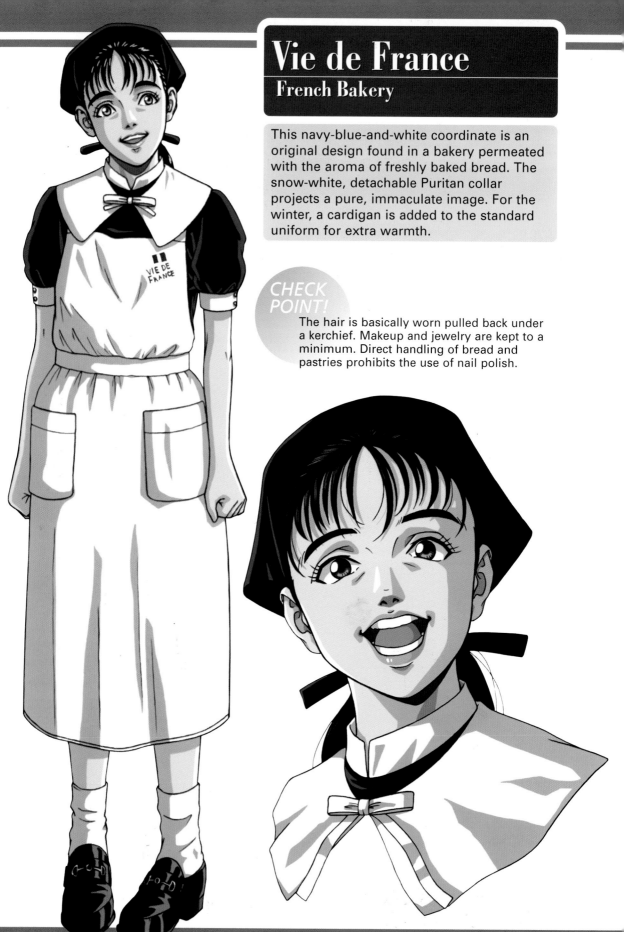

Vie de France
French Bakery

This navy-blue-and-white coordinate is an original design found in a bakery permeated with the aroma of freshly baked bread. The snow-white, detachable Puritan collar projects a pure, immaculate image. For the winter, a cardigan is added to the standard uniform for extra warmth.

CHECK POINT!

The hair is basically worn pulled back under a kerchief. Makeup and jewelry are kept to a minimum. Direct handling of bread and pastries prohibits the use of nail polish.

VIE DE FRANCE

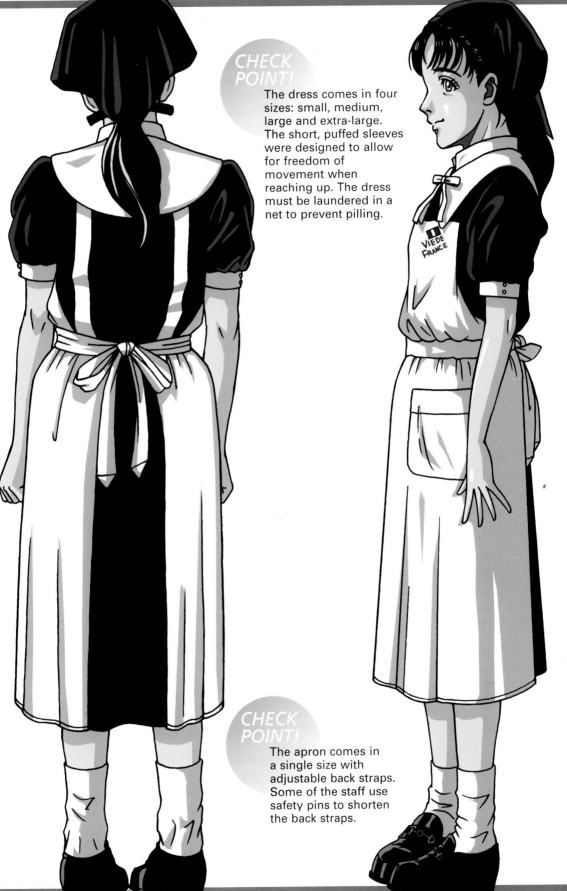

CHECK POINT!

The dress comes in four sizes: small, medium, large and extra-large. The short, puffed sleeves were designed to allow for freedom of movement when reaching up. The dress must be laundered in a net to prevent pilling.

CHECK POINT!

The apron comes in a single size with adjustable back straps. Some of the staff use safety pins to shorten the back straps.

DETAILS

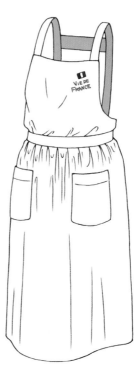

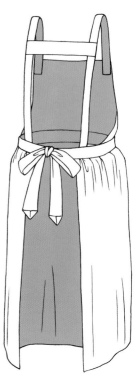

CHECK POINT!

The apron, made of cotton, requires no fuss and can be tossed into the washing machine. The dress's waist is relatively simple in design, and the back has a zipper closure. The shoulders are not padded.

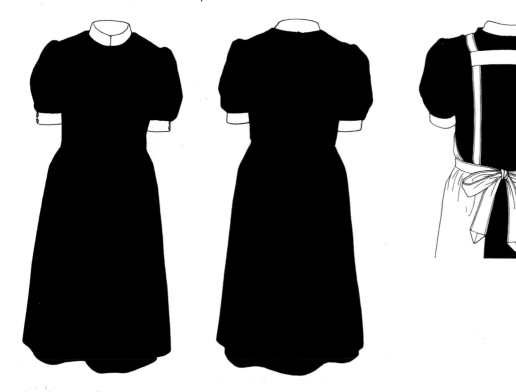

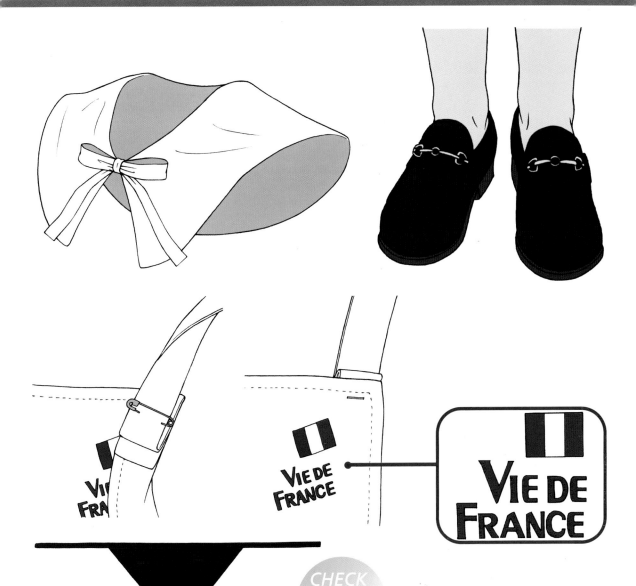

CHECK POINT!

The kerchief includes a band and ties to prevent slipping. The apron's bib is marked with the Vie de France insignia. A badge bearing the employee's name is also pinned to the bib.

SHOP INFORMATION!

Vie de France

Vie de France is a French bakery chain with outlets throughout Japan. Customers enjoy fresh bread and coffee in a café located inside the bakery. The chain also offers a breakfast menu and is conveniently open early in the morning. The manager is usually present on the floor, so the staff members are always on their best behavior and polite toward the customers. Vie de France offers a decidedly relaxing respite, whether it be during the morning commute or for a midafternoon break.

Contributing Branch:
Vie de France, Asagaya Branch
3-58-1 Asagaya Minami,
Suginami-ku, Tokyo
Tel.: 03-3223-6500
Hours: 7:30 a.m. to 8:00 p.m. daily

First Kitchen
Fast-Food Chain

This is a cheery uniform, consisting of oranges and other warm colors coordinated with Bermuda shorts. The First Kitchen policy of always putting "a friendly smile before speed at the register" is evident inside the restaurants, which have an inviting atmosphere. The employees launder and iron the uniforms themselves.

CHECK POINT!

Only the most basic cosmetics are allowed. Clip earrings are strictly forbidden. However, pierced earrings are allowed, provided they are small and unobtrusive. Employees with long hair are required to wear it pulled back. The cap is worn straight on the head.

CHECK POINT!

The shirt is made of cotton, and the shoulders are not padded. The shirt tends to lose its form and is difficult to iron.

CHECK POINT!

The uniform comes in four sizes: small, medium, large and extra-large. Each employee is allotted one uniform. The uniform illustrated here is that worn by the staff members, called "mates." Shoes are either black or brown and are always low-heeled.

DETAILS

CHECK POINT!

A cardigan is added to the uniform in the winter for extra warmth. The First Kitchen insignia appears over the breast along with the employee's nametag.

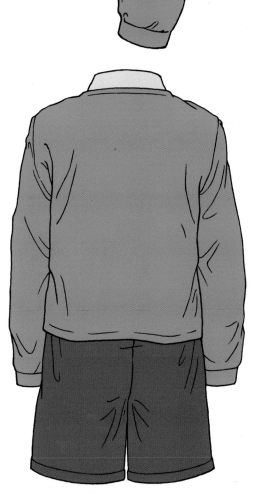

CHECK POINT!

The First Kitchen menu requires significantly more preparation than most, so Bermuda shorts were selected for comfort and ease of movement. A pen is worn attached to a back belt loop.

CHECK POINT!

The necktie and cap both bear the First Kitchen logo. Nametags decorated with four or more stars indicate the employee is a customer-service manager. Employees progress from "mate" (general staff) to "mate trainer" to "customer-service manager." All staff in the position of mate trainer or below are required to wear socks; female customer-service managers are permitted to wear nylons.

SHOP INFORMATION!

First Kitchen
Check out the "Online Coupons" section of First Kitchen's official website for its latest menu offerings. Still, whenever asked "What is your favorite menu item?" the store manager insists nothing beats the Bacon Egg Burger. This First Kitchen specialty is also a favorite among the staff.

Contributing Branch: First Kitchen, Shinjuku Station South Exit Branch, Tokyo
1-18-3 Nishi-Shinjuku, Murakami Bldg., 1st Floor, Shinjuku-ku, Tokyo
Tel.: 03-3348-5389
Hours: 5:00 a.m. to 2:00 a.m. Mondays
4:00 a.m. to 2:00 a.m. Tuesdays through Fridays
3:00 a.m. to 2:00 a.m. Saturdays and days preceding holidays
3:00 a.m. to 1:00 a.m. Sundays
First Kitchen's Official Website:
http://www.first-kitchen.co.jp/

Individual Garments
Blouses

Uniform blouses are categorized in general terms according to their collar and sleeve designs. The illustrations below were adapted from a catalog targeted at businesses. However, most of the restaurants and cafés I researched seemed to use customized versions of what appeared in the catalog. Fast-food chains usually opt for turndown collars and set-in sleeves, while cafés typically select flat collars and shirtsleeves. The neutral mandarin collar seems to be that preferred by beer halls and restaurants.

Common Designs

Collars

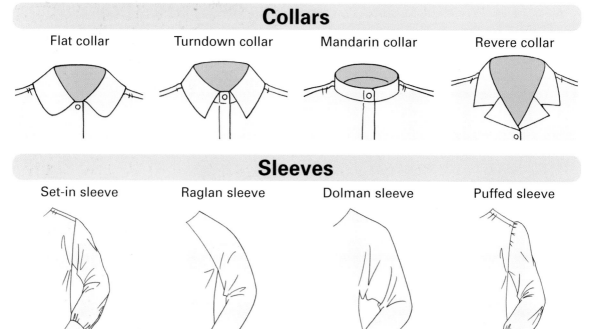

Flat collar Turndown collar Mandarin collar Revere collar

Sleeves

Set-in sleeve Raglan sleeve Dolman sleeve Puffed sleeve

Flat Collars, Polo Collars & Set-in Sleeves

The illustration to the lower left shows a typical flat collar, while the illustration to the right shows a polo-collar shirt. Members of floor staff usually wear their hair tied back, giving clear view of the nape.

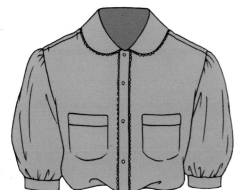

Turndown Collars and Set-in Sleeves

To the left is a club (rounded) collar, while the illustration to the right shows an open-neck collar. The neckband is usually starched.

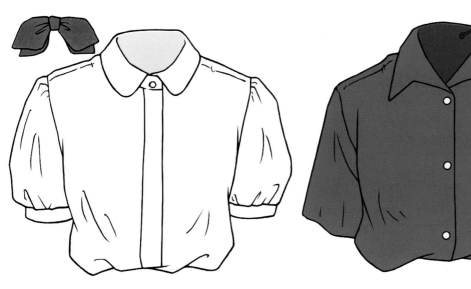

Neckband

Turndown Collar & Set-in Sleeves (Below the Elbow)

Specifically, this is a wide-spread collar. The neck is somewhat large.

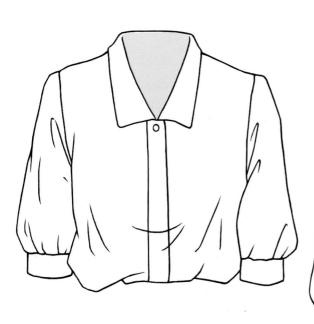

Turndown Collar and Set-in Sleeves (Long)

Here we see a long-point collar. An accessory, such as a brooch, added to the neck produces a stylish accent.

Turndown Collars and Set-in Sleeves (Tailored)

Stripes and buttoned epaulets bring out the shoulders, creating a crisp, tailored look. Shoulder pads are often present.

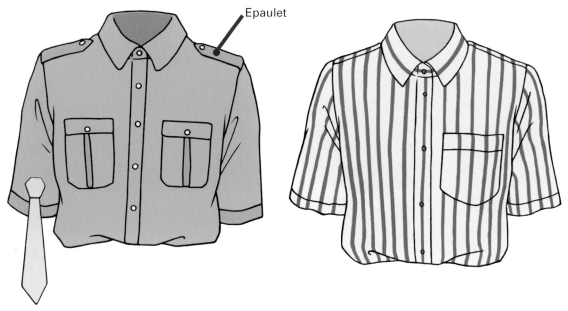

Epaulet

Turndown & Revere Collars and Set-in Sleeves

The illustration to the lower right shows a revere collar. Tucks added to the right and left sides of the front of the blouse, or placket, create a stylish look. Satin and other fabrics with a sheen seem to be favored for this type of design.

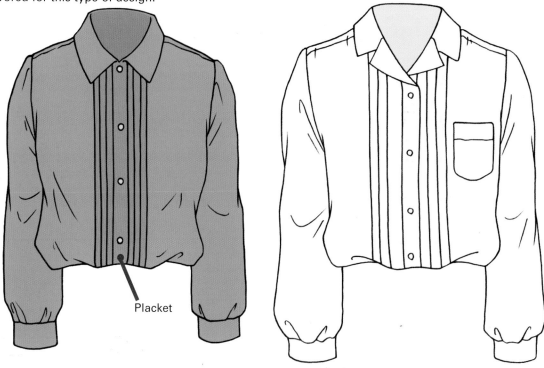

Placket

Mandarin Collars

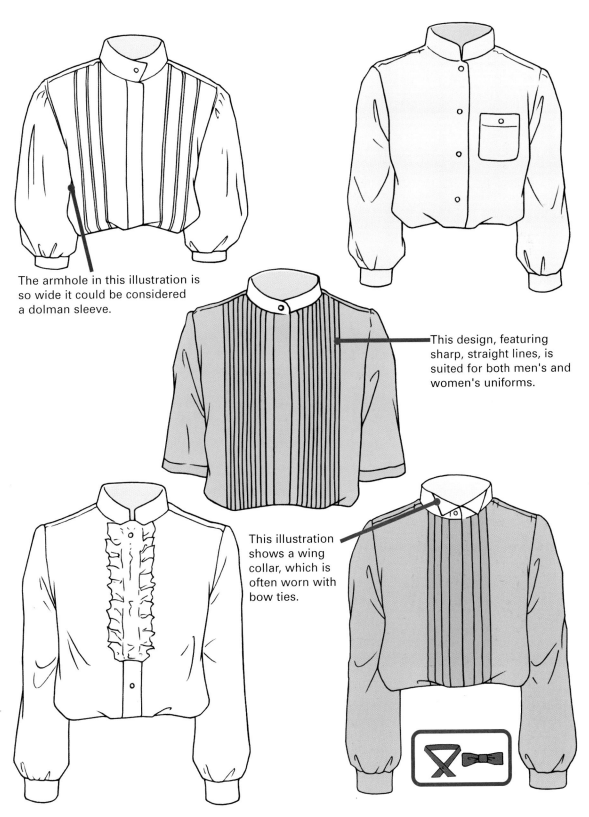

The armhole in this illustration is so wide it could be considered a dolman sleeve.

This design, featuring sharp, straight lines, is suited for both men's and women's uniforms.

This illustration shows a wing collar, which is often worn with bow ties.

Bows

Bows worn with uniforms generally fall into one of two categories: clip-on, which clip to the collar from the front, and pre-tied, which are attached from the back of the neck. Dark colors such as black or dark brown are usually selected to bring out the crisp whiteness of the blouse.

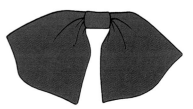

The clip-on bow is typically made by folding a rectangular piece of cloth in half, sewing the edges together, and then gathering the center with a separate piece of cloth.

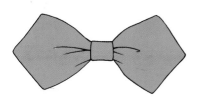

Here are a couple of bows where the edges have been trimmed to add a little more style.

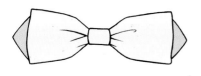

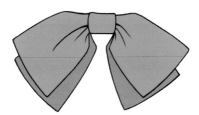

A second piece of cloth is folded in half and then wrapped around the center of the first. Using a slightly different collar creates an interesting contrast for the bow's final design.

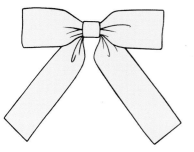

The central knot for this bow was created using a separate piece of cloth.

This illustration shows a classic bow tie tied from a single strip of cloth. Popular among cafés striving for an old-fashioned American atmosphere, this particular bow tie is cotton and is softer than the three shown above.

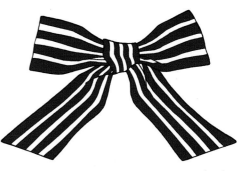

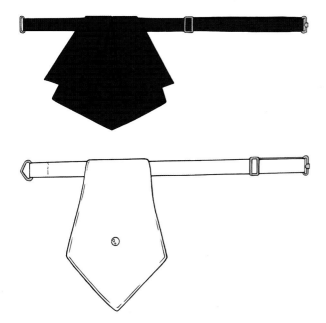

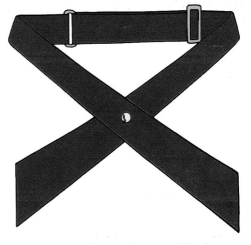

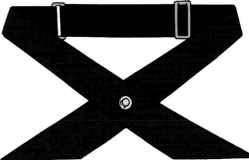

The three cravats illustrated to the left fasten in the back of the neck. The two cross ties fastened in the front (depicted to the right) are adjusted using the back buckles.

Headwear

Headwear is worn for health and sanitary concerns as well as to top off the uniform for a fully coordinated look.

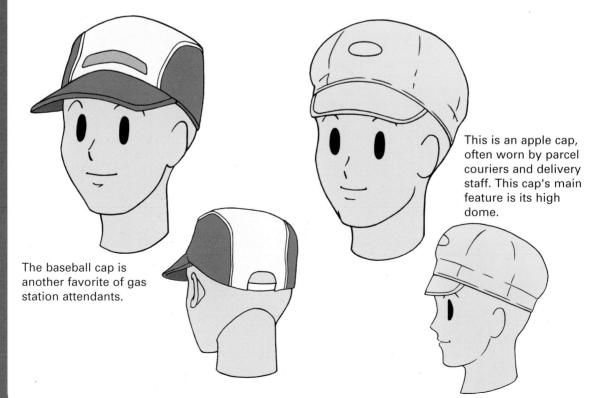

These illustrations show sun visors, popular among gas station attendants. Sun visors are occasionally worn with fast-food uniforms as well.

The kerchief is commonly worn by kitchen staff, as well as the staff at bakeries and shops selling bento (boxed lunches). Kerchiefs generally come in two styles: the traditional square cloth folded into a triangle, and a triangular cloth with a tie sewn as part of the article to facilitate fastening.

This is an apple cap, often worn by parcel couriers and delivery staff. This cap's main feature is its high dome.

The baseball cap is another favorite of gas station attendants.

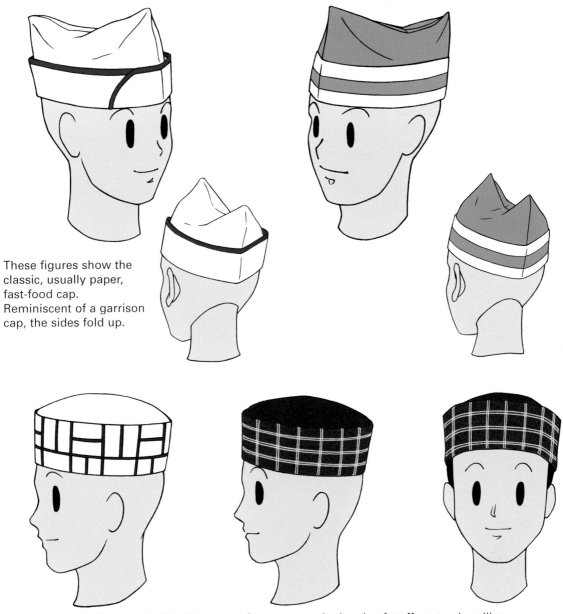

These figures show the classic, usually paper, fast-food cap. Reminiscent of a garrison cap, the sides fold up.

These cylindrical hats are often seen on the heads of staff at stands selling takoyaki (octopus dumplings) and at other traditional Japanese food stalls.

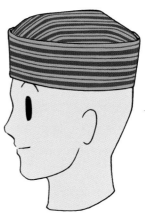

Two caps styled after the type of hats traditionally worn by sailors.

Aprons

Aprons generally fall into the following three categories: pinafores, bib (full) aprons and waist aprons. Each of the cafés and other establishments I visited seemed to be trying out various ways to make their uniform designs more appealing.

Waist Aprons

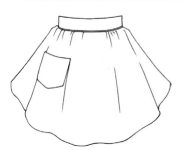

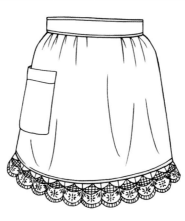

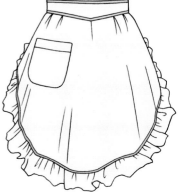

The center illustration shows an apron of an even length, similar to a skirt.

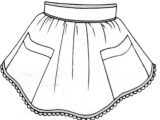

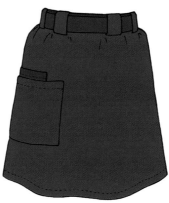

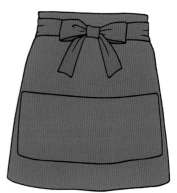

This apron forms a shell-like shape when laid flat. When worn, the hemline rises as it wraps toward the back. Function is emphasized in the two aprons to the right, which do not flare. Aprons that lace around the front are often found at Japanese restaurants.

Bib Aprons

These are full aprons that include a bib and have straps made of pieces separate from the main skirt and bib. They seem to be favored by the more casual restaurants and cafés.

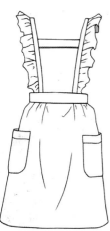

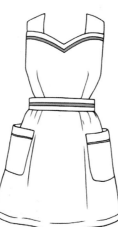

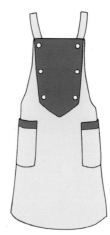

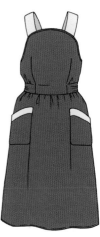

Pinafores

Both the tops and bottoms of these aprons are made of the same material. Pinafores are often worn over a dress. There are also styles where the top is structured like a vest and is separate from the apron's skirt.

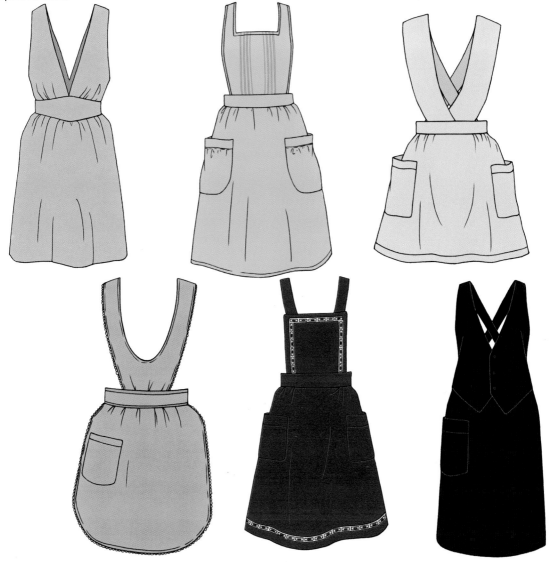

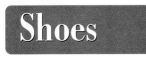
Shoes

Most part-time employees wear either low-heeled leather oxfords or loafers. Alternatively, some wear athletic shoes. Colors tend to be relatively simple: brown, white or black.

Hediard

Café and Cake Shop

This is a popular design inspired by fashions favored by young European women. The eye-catching apron is decorated with the style of embroidery practiced in France's province of Brittany, adding an air of authenticity. The uniform's main colors are white, black and red, painting an understated image. The uniform is so delightful, one would never guess its individual pieces were actually purchased retail and then modified rather than tailor-made to suit the café. The colors used in the uniform were selected to match the café's interior.

CHECK POINT!

Only a minimal amount of makeup is allowed —just enough to present a clean, professional appearance. Nail polish is not permitted. Jewelry is limited to non-dangling, pierced earrings and wedding bands. Clip-on earrings are strictly forbidden.

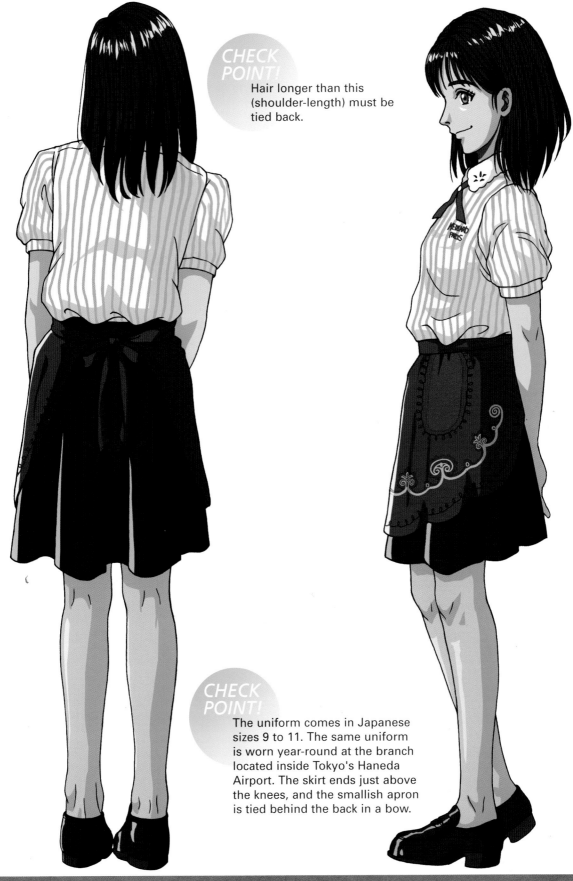

CHECK
POINT!

Hair longer than this
(shoulder-length) must be
tied back.

CHECK
POINT!

The uniform comes in Japanese
sizes 9 to 11. The same uniform
is worn year-round at the branch
located inside Tokyo's Haneda
Airport. The skirt ends just above
the knees, and the smallish apron
is tied behind the back in a bow.

DETAILS

CHECK POINT!

The two main pieces are a solid-colored blouse and an above-the-knee, flared skirt. The flaring simultaneously adds charm to the skirt and allows ease of movement. The sleeves are short and have tucks. The shoulders are not padded.

CHECK POINT!

The apron, which is exquisitely decorated with yellow-and-red embroidery, is a blend of cotton and polyester. Dry cleaning is the preferred method for laundering, as it keeps the uniform looking immaculate and new.

CHECK POINT!

The blouse has cream-colored stripes that are so light they approach ivory. The collar is decorated with leaf-shaped openwork. There is no particular style of shoe designated for this uniform, but black pumps or loafers with heels of 5 centimeters (approximately 2 inches) or shorter are preferred. Stockings are either black or brown to maintain a well-coordinated image.

SHOP INFORMATION!

Hediard

The branch I researched was located in the basement of Haneda Airport's domestic terminal, dubbed "Big Bird." Crépes, prepared from a recipe learned by the chef while in Paris, are a main feature on the café's menu. The sweet aroma of the crépes wafts from the glass-windowed interior to the passageway outside. The green, orange and crimson-embroidered aprons are refreshing and vibrant. The apron seems to appeal as well to the staff, who graciously posed very delightfully for me.

Contributing Branch: Hediard, Haneda Airport Branch
3-3-2 Haneda Airport, Ota-ku, Tokyo
Tel.: 03-5757-9292
Hours: 7:00 a.m. to 8:00 p.m. daily
(Last orders taken at 7:30 p.m.)

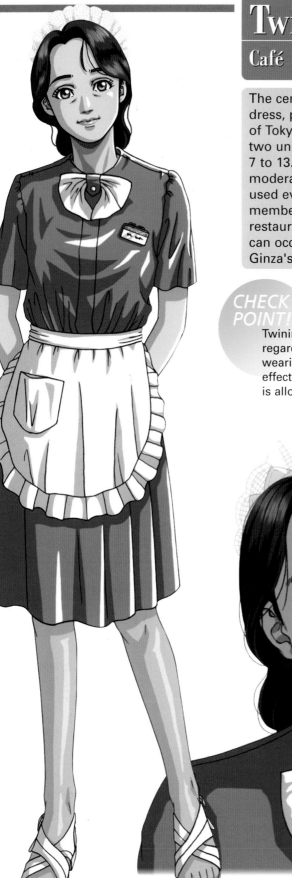

Twinings
Café

The centerpiece of this uniform is its elegant dress, perfect for the upscale Ginza district of Tokyo. Each employee is supplied with two uniforms, which come in Japanese sizes 7 to 13. The interior of the café receives moderate sunlight, so the same uniform is used even during the winter. The staff members also run errands outside the restaurant in their Twinings uniforms and can occasionally be spotted waiting at Ginza's busy crosswalks.

CHECK POINT!

Twinings does not have any particular rules regarding cosmetics, but none of the staff was wearing heavy makeup (perhaps the result of effective training?) during my visits. Jewelry is allowed, provided it is not excessive.

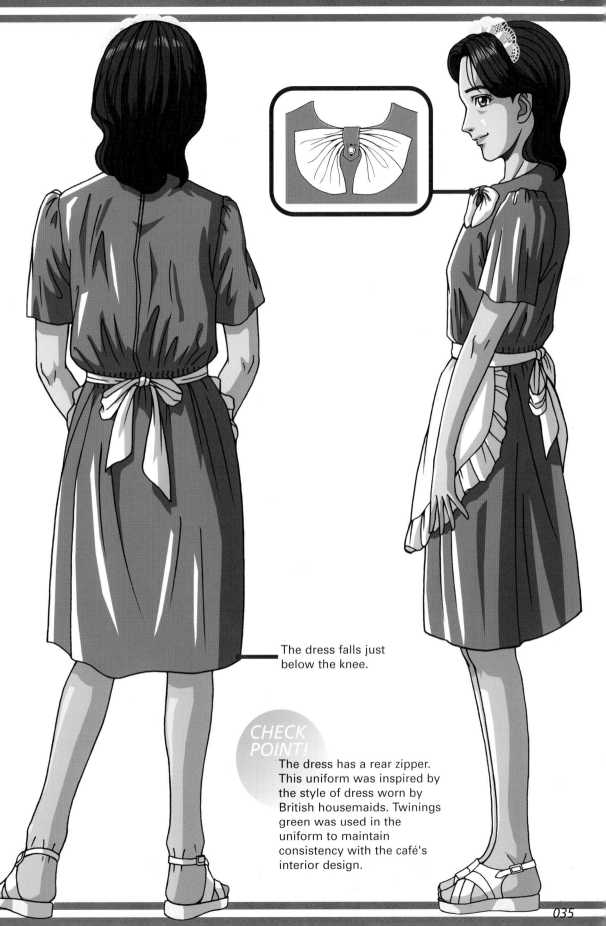

The dress falls just
below the knee.

**CHECK
POINT!**

The dress has a rear zipper.
This uniform was inspired by
the style of dress worn by
British housemaids. Twinings
green was used in the
uniform to maintain
consistency with the café's
interior design.

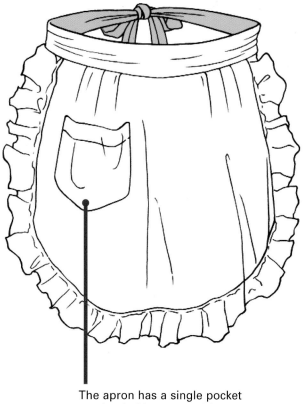

A nametag bearing the Twinings logo is worn over the left breast.

The apron has a single pocket used to hold a notepad for taking orders.

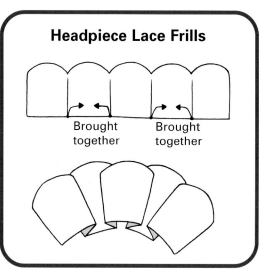

Headpiece Lace Frills

Brought together Brought together

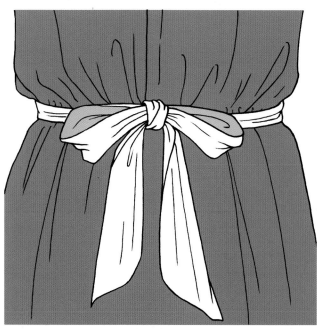

CHECK POINT!

The apron is short and worn around the waist. Since the entire uniform is dry cleaned, the apron is always snowy white. The hemline is bordered with large ruffles made from the same fabric as the rest of the skirt.

Detailed lace is sewn to the headpiece.

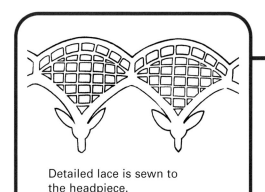

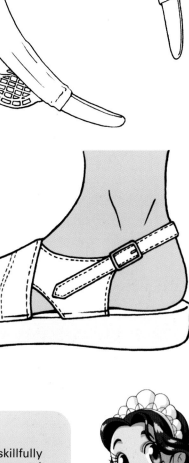

CHECK POINT!

Nurses' sandals are worn with the Twinings uniform, perhaps because they are comfortable and easy to wear for extended periods. Only beige or flesh-toned nylons are permitted.

SHOP INFORMATION!

Twinings
I conducted my research at a Twinings branch located on the fourth and fifth floors of a building on a street corner in Ginza. The interior, bathed in sunlight, was filled with women resting and chatting after a day of shopping. The fine porcelain ware coordinated well with the light-slate-blue uniforms. The waitresses modulated their voices when taking orders and skillfully balanced plates and cups to and from the tables, in keeping with the café's sophisticated atmosphere.

Contributing Branch: Twinings, Ginza Branch
5-7-2 Ginza, San-ai Bldg.,
4th and 5th floors
Chuo-ku, Tokyo
Tel.: 03-3289-2311
Hours: 11:00 a.m. to 10:30 p.m. daily

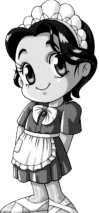

Half Dime

Diner

Likely the only chain of its kind, the interior of this restaurant is designed to resemble a gold mine. The concept was inspired by the California Gold Rush, which sparked settlement of the western United States. The name "Half Dime" was derived from the American 10-cent coin, the dime. According to the story promoted by the restaurant, a miner who struck gold in California would split a silver dime and send one half to his bride waiting at home and keep the other half for himself. The eight to 15 floor staff members present all wear different costumes. Seeing all of them together presents quite a spectacle.

JAWS

This costume, which is only worn during the summer, appears as if a shark is swallowing the wearer. The headpiece was special-ordered and is hollow on the inside, making it lightweight and easy to wear. The shirt, shorts and socks are all color-coordinated.

Angel

I was not able to see the angel costume when I visited the restaurant. However, the angel, the Statue of Liberty and the woodpecker costumes are all favorites of the female staff. This particular costume is composed of a skirt and blouse. The skirt has three layers of petticoats underneath. The halo is made of clear plastic and is attached to a headpiece. The wings are made of cloth and contain a frame to maintain their shape.

Babe Ruth

This costume pays homage to the Sultan of Swat. The garment is a faithful reproduction of a baseball uniform actually worn during the early part of the 20th century, when the Babe was in his prime. Instead of a team name, the cap bears the Half Dime logo.

DETAILS

Catwoman

This costume is based on that worn by the famous villain who first appeared in the *Batman* comic book series. Modified to suit Half Dime's needs, everything from the outer bodysuit to the one-piece cat suit underneath to even the belt itself were special-ordered. The hood attached to the cat suit was originally worn on the head, but it looked unattractive, so new ears were added instead.

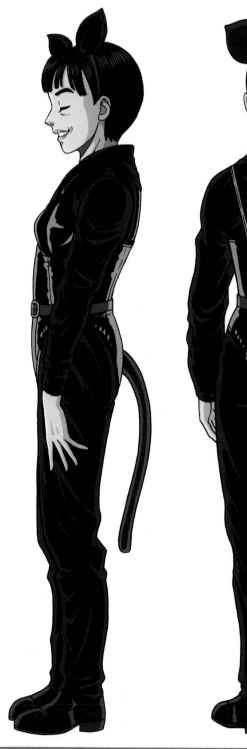

CHECK POINT!

The two main pieces are a solid-colored blouse and an above-the-knee, flared skirt. The flaring simultaneously adds charm to the skirt and allows ease of movement. The sleeves are short and have tucks. The shoulders are not padded.

CHECK POINT!

The staff is allowed to purchase and bring their own props (tails, maracas, swords, etc.). The restaurant also holds events in which staff members make themselves up even more elaborately.

CHECK POINT!

Hair longer than shoulder-length must be tied back. Necklaces and rings are not allowed. Pierced earrings are permitted, provided they match the theme of the costume. Since the lighting is dimmed for the dinner service, light- and dark-toned lipstick are not permitted. Perfume and nail polish are forbidden.

SHOP INFORMATION!

Half Dime
Half Dime strives to create a casual, special atmosphere. The restaurant manager insists that functionality has been disregarded. Keeping in line with the atmosphere, which is intended to evoke excitement and delight among the patrons, 25 different costumes were designed to act as icebreakers for making conversation with the customers. Half Dime hosts numerous events, which are designed with care to suit the season. Santa and his reindeer even make their appearance at Christmas. The restaurant actively embraces the ideas of its staff. So, for those looking for a part-time job, working here can create quite a sense of fulfillment.

Contributing Branch: Half Dime, Kawagoe Branch
5-3 Wakitashinden
(Located inside Sanrio Farm)
Kawagoe-shi, Saitama Prefecture
Tel.: 0492-42-3581
Hours: 11:00 a.m. to 2:00 a.m. daily
Lunch: 11:00 a.m. to 5:00 p.m.
(except Sundays and holidays)

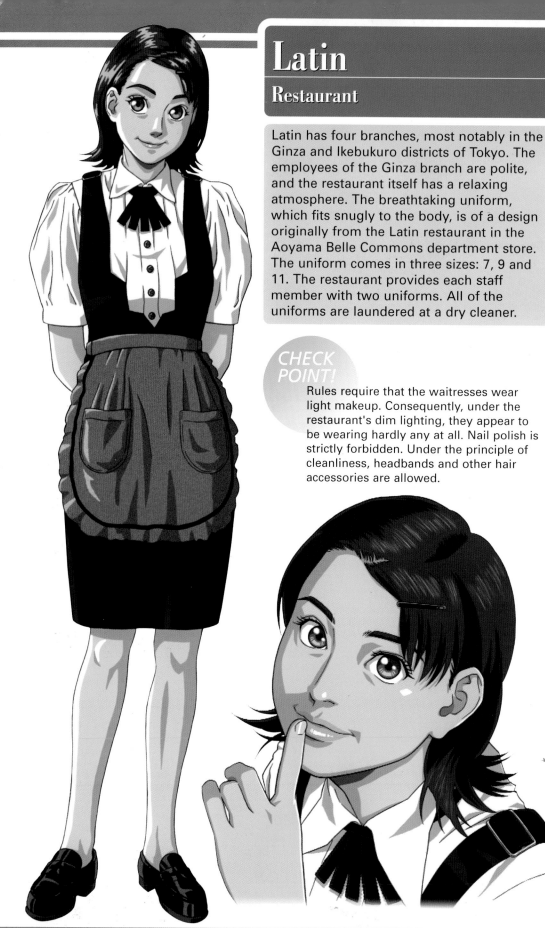

Latin

Restaurant

Latin has four branches, most notably in the Ginza and Ikebukuro districts of Tokyo. The employees of the Ginza branch are polite, and the restaurant itself has a relaxing atmosphere. The breathtaking uniform, which fits snugly to the body, is of a design originally from the Latin restaurant in the Aoyama Belle Commons department store. The uniform comes in three sizes: 7, 9 and 11. The restaurant provides each staff member with two uniforms. All of the uniforms are laundered at a dry cleaner.

CHECK POINT!

Rules require that the waitresses wear light makeup. Consequently, under the restaurant's dim lighting, they appear to be wearing hardly any at all. Nail polish is strictly forbidden. Under the principle of cleanliness, headbands and other hair accessories are allowed.

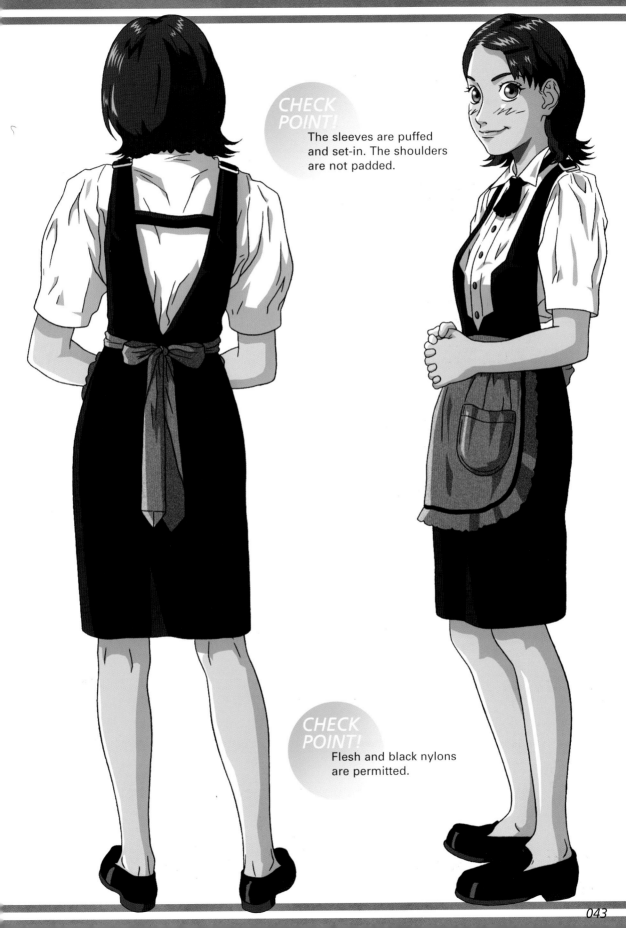

CHECK
POINT!

The sleeves are puffed
and set-in. The shoulders
are not padded.

CHECK
POINT!

Flesh and black nylons
are permitted.

DETAILS

CHECK POINT!

The upper half of the jumper opens in the front from an upside-down triangle combined with a rectangle. The back opens from a deep, plunging V. Made of 100% polyester, the uniform has a black sheen.

CHECK POINT!

The apron is 100% cotton and comes in gray—an unusual color for such a garment. The apron's design is typical of that worn by employees of beauty salons. Both the right and left sides have pockets. The ends are tied in a bow in back.

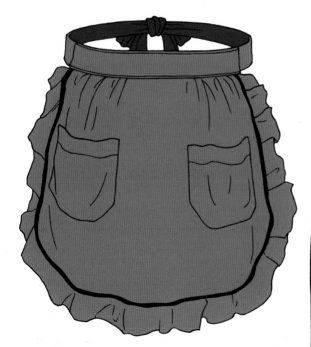

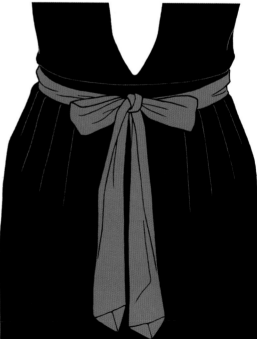

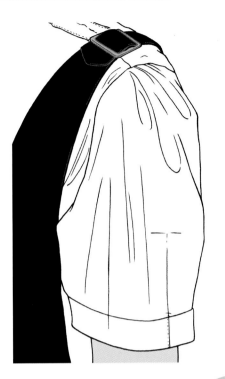

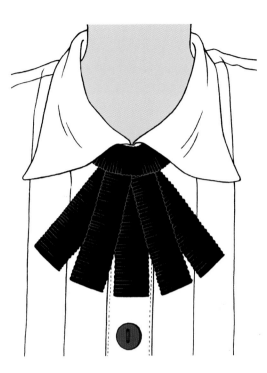

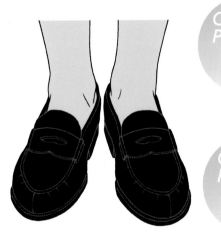

CHECK POINT!

The ribbon decorating the collar is fastened in back. The ribbon actually consists of five trailing pieces—two on top, three on the bottom—sewn together. The blouse has half-sleeves that end just above the elbows, and is worn year-round. The restaurant manager said that ease of movement was emphasized in the design.

CHECK POINT!

Waitresses are required to wear shoes with heels that are 5 centimeters (about 2 inches) in height or less. When I visited the restaurant to conduct my research, everyone was wearing flats of the sort worn to school, thereby creating a casual impression.

SHOP INFORMATION!

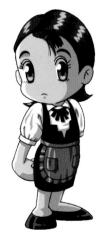

Latin
The Ginza Latin is tucked away in one of the district's underground shopping arcades, and is therefore a relatively well-kept secret. The uniform worn by the waitresses at the Ginza location is very feminine and is composed of skillfully coordinated and modified designer brand pieces. At the chain's other restaurants, different uniforms are worn, each chosen to best suit the neighborhood. The restaurant's menu is Italian and the atmosphere is cheerful.

Contributing Branch: Latin, Ginza Branch
Ginza 4-chome, Kintetsu Bldg.,
basement second level
Chuo-ku, Tokyo
Tel.: 03-3564-0485
Hours: 8:00 a.m. to 10:30 p.m.
　　　Mondays through Saturdays
　　　10:30 a.m. to 10:30 p.m.
　　　Sundays and holidays

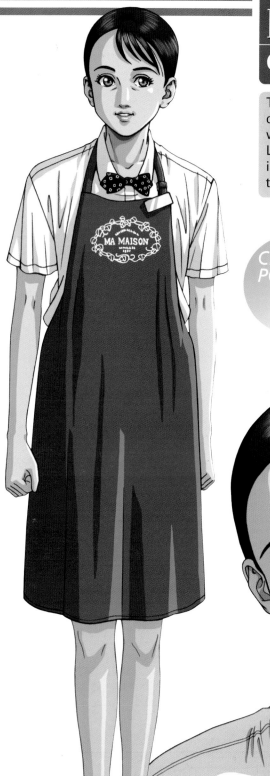

Ma Maison

Café & Restaurant

The interior is that of an old-fashioned, casual European café. The uniforms worn by waitresses were designed by Yves Saint Laurent and project a highly chic, refined image. The red of the apron complements the color scheme of the restaurant itself.

CHECK POINT!

The restaurant's rules are strict: Accessories are prohibited, and hair falling below the shoulder must be tied back in a bun. Needless to say, nail polish is also a no-no.

CHECK POINT!

The uniform comes in two sizes: 7 and 9. The restaurant provides each employee with one uniform, and the employee is responsible for having the uniform dry-cleaned herself. A long-sleeved blouse is worn with the uniform in the winter, but the apron remains the same. The material is cotton. The shoulders are unpadded.

CHECK POINT!

The skirt is fitted and knee-length. The apron is just long enough to cover the skirt and ties below the waist.

CHECK POINT!

The staff is required to wear shoes with low heels. Slingbacks are prohibited. Flesh tone is the standard color accepted for nylons, but black is also permitted during the winter. What is impressive is that while the bow and apron are the café's designs, everything else is from the Yves Saint Laurent collection.

CHECK POINT!

The apron is worn by slipping it over the head. However, since the length cannot be adjusted with the back straps, it is worn loosely. The straight skirt projects a casual, European image. Some of Ma Maison's branches have uniforms with white aprons and floral-print skirts.

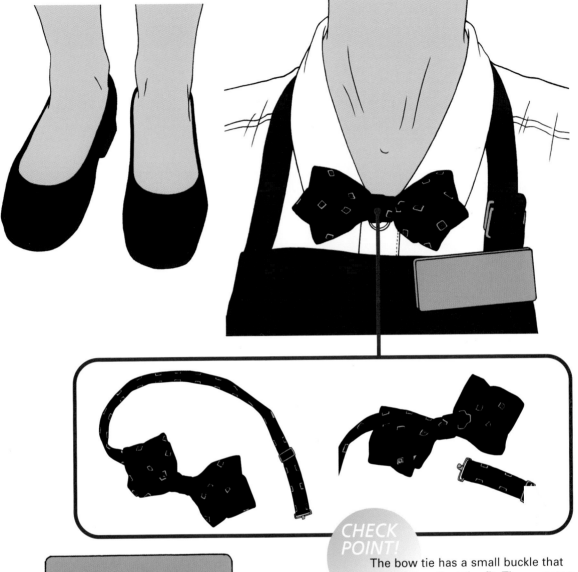

CHECK POINT!

The bow tie has a small buckle that is used to adjust the fit. The nametag bears the restaurant's logo.

SHOP INFORMATION!

Ma Maison
This restaurant serves delicious pasta dishes in a stylish but casual atmosphere. I conducted my research at Ma Maison's branch in the Ome district of Tokyo. The interior is based on the dining room of a European-style home, and both the lighting and the music played in the background are subdued and sophisticated. The menu contains a wide variety of dishes, and the servings are generous. The waitresses are trained to treat customers as if they were guests in the staff's own homes.

Contributing Branch: Ma Maison, Ome Branch
4-21-4 Shin-machi
Ome-shi, Tokyo
Tel.: 0428-31-8877
Hours: 11:00 a.m. to 11:00 p.m. daily

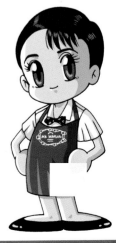

Sapporo Lion
Beer Hall

The Sapporo Lion's Ginza branch was built in 1934, which makes it Japan's oldest beer hall. With its high ceiling and inlaid-glass mosaic, the interior speaks of Ginza's halcyon days, creating a secure, tranquil atmosphere. The waiters and waitresses receive thorough training and are instructed to remember the names and faces of regular customers.

CHECK POINT!

Sapporo Lion does not have strict rules regarding jewelry. Pierced earrings are acceptable, provided they are small (non-dangling), and necklaces are also permitted, so long as they are not visible. Waitresses are allowed to wear hair any way desired, provided it is pulled back in some fashion. However, colored ponytail bands and ribbons are forbidden.

CHECK POINT!

The uniform comes in four sizes: small, medium, large and extra large. The employees share the uniforms, and the restaurant does not provide personal uniforms to its staff.

CHECK POINT!

The restaurant calls its uniform "the Tyrolean" (after Tyrol, an alpine region in western Austria and northern Italy). Naturally, the design is Swiss. Although the uniform was not intentionally designed to coordinate with the interior, it does reflect the interior's warm, woody flavor. The garment's designer could be considered the originator of all uniforms of this style, yet no one knows who he or she was. A professional dry cleaner handles all of the laundering.

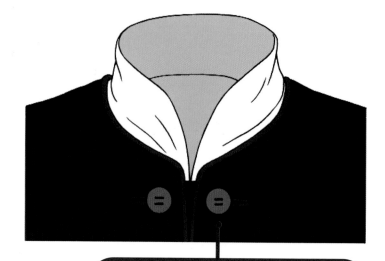

CHECK POINT!

The chestnut buttons are wrapped in a silky embroidery thread. This is a slightly complicated design: The buttons of the dress underneath are fastened through the buttonholes of the waistcoat worn on top. The green of the waistcoat is reflected in the Tyrolean pattern along the hem of the skirt.

CHECK POINT!

The geometrical shapes of the pattern along the hem function as an accent. The uniform is matched with black sandals, similar in design to the white sandals worn by nurses. The employees are required to supply their own nylons. Only flesh tones and black are permitted.

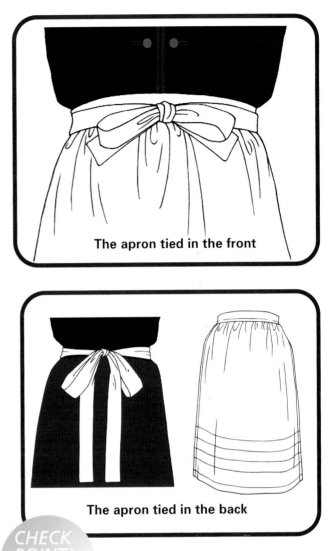

The apron tied in the front

The apron tied in the back

CHECK POINT!

The apron is made of white nylon and has tucks around the hemline. The apron's lines are simple, and it is not trimmed with ruffles. The unusual habit of tying the apron in front is functional in purpose and apparently was started to prevent the loops of the bow from catching on chairs.

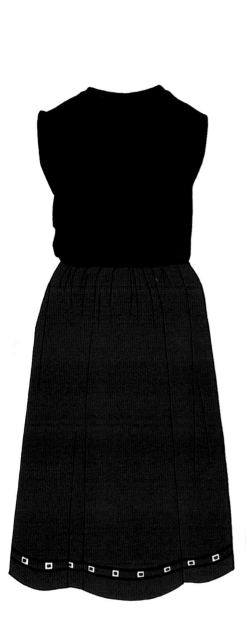

SHOP INFORMATION!

Sapporo Lion
The staff's training and comportment are close to perfect. On weekday afternoons, the restaurant is always bustling with mature men relaxing with a beer and couples stopping by after a day strolling around Ginza. In the evenings, the restaurant is alive with boisterous employees from around Ginza just getting off work.

Contributing Branch: Sapporo Lion Ginza 7-chome Branch
7-9-20 Ginza, Ginza Lion Bldg., 1st Floor Chuo-ku, Tokyo
Tel.: 03-3571-2590
Hours: 11:30 a.m. to 11:00 p.m.
Monday through Saturdays
11:30 a.m. to 10:30 p.m.
Sundays and holidays

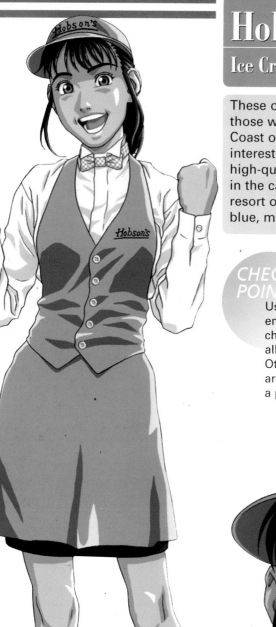

Hobson's
Ice Cream Parlor

These original uniforms were inspired by those worn in resort areas on the West Coast of the United States. This arose from interest in creating a shop with the same high-quality customer service as that found in the cafés and restaurants run by those resort operators. The uniform's main color is blue, matching the shop's interior.

CHECK POINT!

Use of cosmetics is for the most part left to the employee's discretion; however, it must project a cheerful, clean image. Rings and nail polish are not allowed, since the employees must handle food. Other accessories are permissible, provided they are not large or gaudy. Long hair must be tied in a ponytail.

CHECK POINT!

The skirt comes in three sizes: 7, 9 and 11. The shirt, vest and apron are all one-size-fits-all. The shop provides two or three shirts to each employee, but only supplies one of each of the other garments. The employees are required to launder and iron the uniforms themselves.

CHECK POINT!

The sleeves are closely fitted, so they tend to ride up when the employee is working. The shoulders are unpadded.

CHECK POINT!

Shoes are leather loafers in either black or brown with low or flat heels. Nylons are permitted provided they are flesh-toned and give the appearance that the legs are bare.

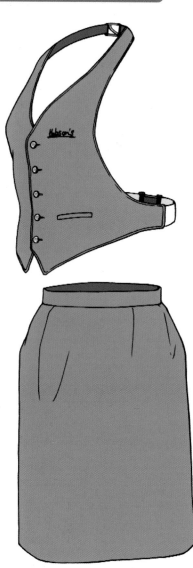

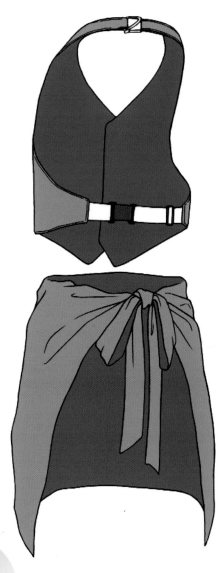

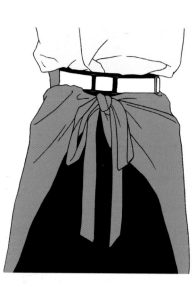

CHECK POINT!

As is illustrated above, the apron consists of two pieces. In addition to the vest-and-skirt set shown—popular in beauty salons as well—there is also a regular, one-piece full version. The vest-skirt set is cut on the short side. The skirt is made of synthetic fibers. Staff members adjust the skirt so it falls above the knees. The uniform is worn with a button-down oxford and a jacket bearing the Hobson's logo.

CHECK POINT!

The apron is without gathers and fitted. The stays are tied from behind below the belt.

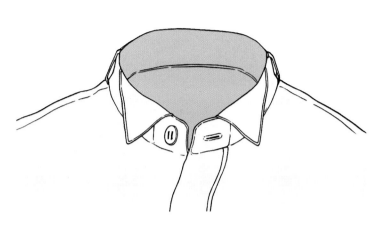

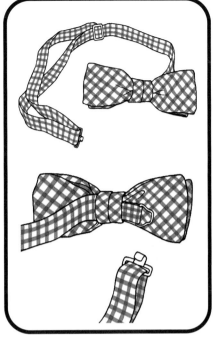

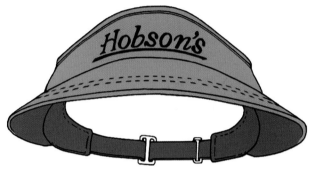

CHECK POINT!

A sun visor, made of the same cotton as the apron, is worn to prevent hair from falling in the eyes. The apron also comes in a tie-in-the-front version. The apron, shirt and visor all bear the Hobson's logo.

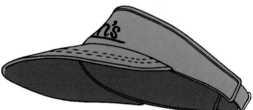

SHOP INFOMATION!

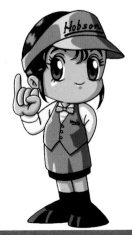

Hobson's

Any girl with a sweet tooth is familiar with this ice cream chain. The interior is overflowing with cheerfulness and is very tidy, indicative of its origins in the California resort town of Santa Barbara. The staff projects a healthy impression and offers prompt and eager service, perhaps because the employees are trained to behave as though the place is much more than a simple ice cream shop.

Contributing Branch: Hobson's, Roppongi Branch
7-8-7 Roppongi,
2 Matsuda Bldg. II, 1st Floor
Minato-ku, Tokyo
Tel.: 03-3479-4610
Hours: Noon to 1:00 a.m. daily

Peltier

Café

The flagship of this chain of pastry shops is located in Paris. The warm and cozy, woody interior was inspired by Provence, the region of southeastern France that is credited with introducing and propagating the French style in Japan. Decorated with vibrantly colored sofas and walls of polycarbonate (a translucent material), the interior echoes with feminine sensibility. The uniforms worn by employees are equally attractive, reflecting the interior.

CHECK POINT!

To ensure customers feel comfortable, the staff is prohibited from outlandish or conspicuous dress. Cosmetics are allowed to the extent that they help present a well-groomed appearance. Only natural colors are permitted. Hair is normally tied in the back.

CHECK POINT!

The uniform is offered in Japanese sizes 7, 9, 11 and 13. The café provides each employee with two uniforms. The uniform is made of rayon, and the café has the garments cleaned by a professional dry cleaner. Originally, the uniforms had been part of a garment distributor's collection, but the café now has its uniforms tailor-made.

CHECK POINT!

In addition to the uniform shown on these pages, there is a Peltier branch in a department store whose uniform consists of a jumper and a beige blouse. At the time I conducted my research, the uniform of the chief branch in Japan was in the process of being redesigned.

DETAILS

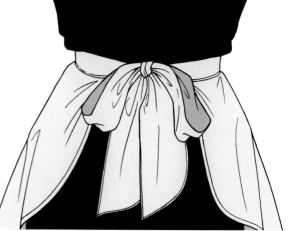

CHECK POINT!

The apron is short, full and gathered at the waist. Two large pockets hold pens and small utensils.

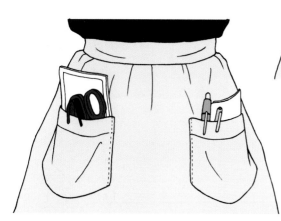

The nametag is displayed to the left above the breast.

CHECK POINT!

The dress's collar is wide and white, similar to those worn with Buster Brown suits, and is fitted to the neck. The collar is fastened in the back with snaps on the right and left sides, and opens as is shown in the illustrations. The snap closure seems difficult to handle alone.

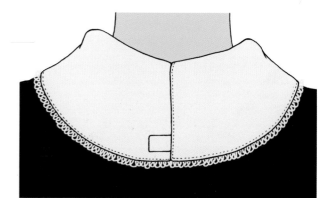

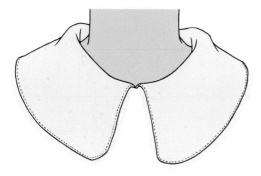

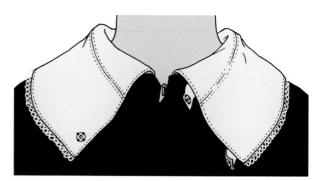

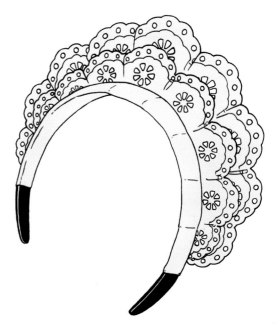

CHECK POINT!

The headpiece is decorated with two layers of lace. The lace's design is intricate: Both layers follow a scalloped pattern, the detailing of which again contains delicate scalloping. The lace is decorated with openwork in the shape of a seven-petaled flower.

CHECK POINT!

The employees are required to supply the shoes themselves. The basic styles permitted are leather low heels and flats in either black or brown. Nylons must be flesh-toned.

SHOP INFORMATION!

Peltier
The wine-red dress of the uniform reflects a sedated, sophisticated sensibility. The interior, including its flooring, classic wooden furniture and aroma of freshly baked bread, was modeled after the living rooms of homes in the Provence region. The staff's training, targeted toward creating a homey atmosphere, is excellent.

The employees are not only required to remember the regular customers, but people from around the neighborhood.

Contributing Branch: Peltier Harajuku (Chief Branch)
6-2-9 Jingumae
Shibuya-ku, Tokyo
Tel. 03-3499-4791
Hours: 11:00 a.m. to 9:00 p.m. daily
(Last orders taken at 8:30 p.m.)

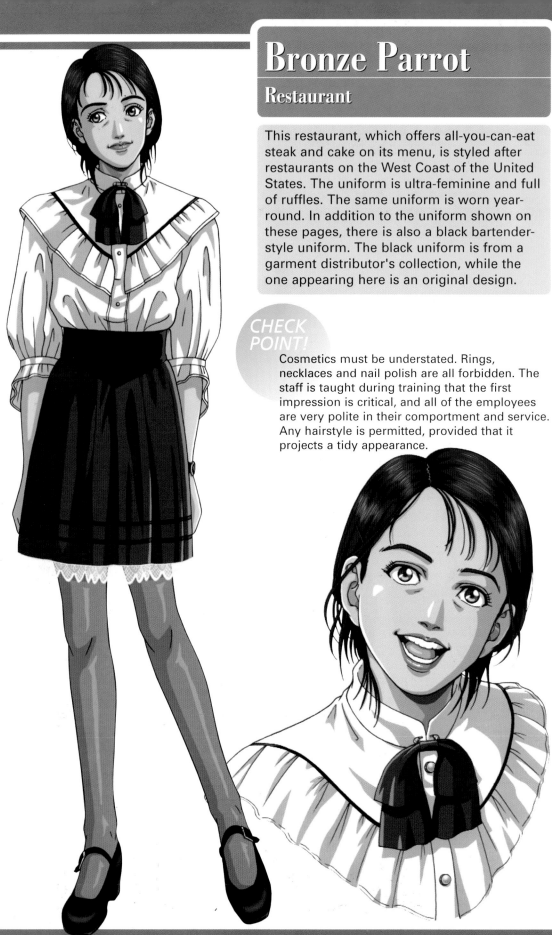

Bronze Parrot
Restaurant

This restaurant, which offers all-you-can-eat steak and cake on its menu, is styled after restaurants on the West Coast of the United States. The uniform is ultra-feminine and full of ruffles. The same uniform is worn year-round. In addition to the uniform shown on these pages, there is also a black bartender-style uniform. The black uniform is from a garment distributor's collection, while the one appearing here is an original design.

CHECK POINT!

Cosmetics must be understated. Rings, necklaces and nail polish are all forbidden. The staff is taught during training that the first impression is critical, and all of the employees are very polite in their comportment and service. Any hairstyle is permitted, provided that it projects a tidy appearance.

CHECK POINT!

The uniform comes in three sizes: 7, 9 and 11. Each employee is typically supplied with one uniform. However, staff members serving both as "companions" and "mates" are supplied with a uniform for each job. A professional dry cleaner handles all of the laundering.

CHECK POINT!

There are no particular rules regarding the shoes, but most of the staff members wear black low heels. Black stockings are required, and they provide a nice contrast to the lace of the skirt's hem.

DETAILS

CHECK POINT!

The skirt falls to just above the knees and has umbrella pleats. The pleats taper at the waist and widen as they approach the hemline. The skirt swirls and opens prettily like a flower whenever the wearer turns.

CHECK POINT!

The waistband, which has the look of a cummerbund, widens and angles at the front. Velcro rather than hooks or snaps are used at the rear closure. The waistband causes the skirt to take on an appearance reminiscent of a tutu.

CHECK POINT!

Clothes of this sort would not be suited to doing the dishes, so the blouse's sleeves have been designed to fall just below the elbows. The ruffled cuffs are gathered at the band, making this almost a half-sleeve.

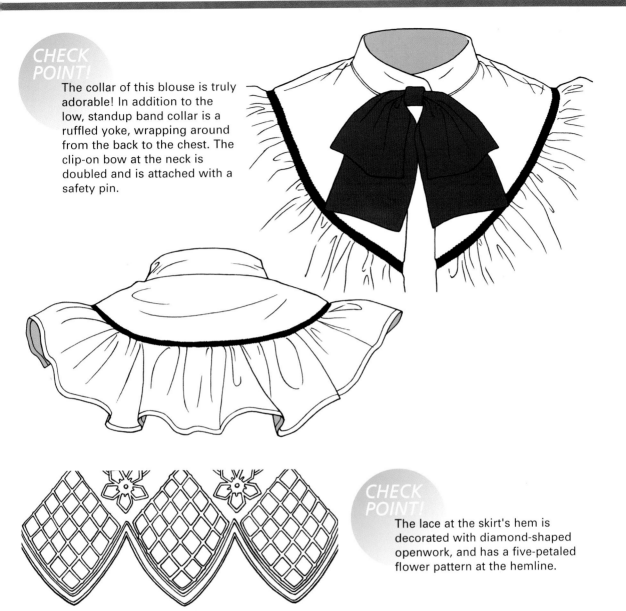

CHECK POINT!

The collar of this blouse is truly adorable! In addition to the low, standup band collar is a ruffled yoke, wrapping around from the back to the chest. The clip-on bow at the neck is doubled and is attached with a safety pin.

CHECK POINT!

The lace at the skirt's hem is decorated with diamond-shaped openwork, and has a five-petaled flower pattern at the hemline.

SHOP INFORMATION!

Bronze Parrot
This café/restaurant, which is part of the Fujiya restaurant group, is famous for its attractive work outfits. This uniform, which gives its wearer the appearance of an adorable French doll, has a large, hardcore fan base, and it is rumored that some of the part-time staff sought work just to wear the uniforms. I conducted my research at the branch in Tachikawa, Tokyo. In addition to the uniform shown here, the Tsurumi Terao branch in

Yokohama also has a brown uniform. The restaurant manager said that the staff's approach toward service is determined by each employee's comportment and attitude. When I was there, the staff's treatment of the customers was very cheerful and polite.

Contributing Branch: Bronze Parrot, Tachikawa Hinobashi
5-19-14 Nishiki-cho
Tachikawa-shi, Tokyo
Tel.: 042-527-0310
Hours: 11:00 a.m. to 2:00 a.m. daily

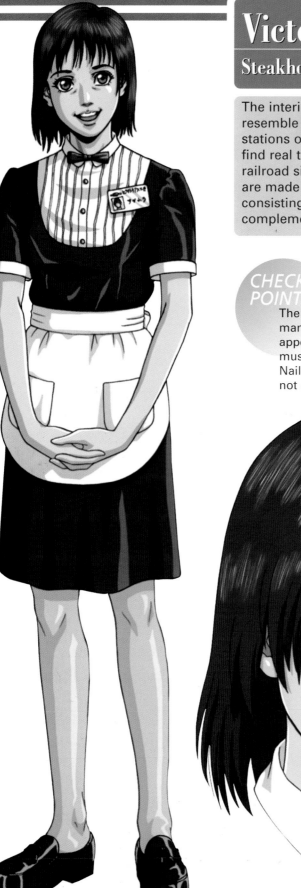

Victoria Station

Steakhouse

The interior of this restaurant is designed to resemble European and U.S. railroad stations of yesteryear. Inside, patrons will find real train passenger cars and antique railroad signs. The floors of the restaurant are made of wood. The restaurant uniform, consisting of a subdued brown dress, complements the interior design.

CHECK POINT!

The staff is required to wear makeup in a manner that projects a clean, professional appearance. Hair longer than that shown must be tied in a ponytail or worn in a bun. Nail polish and rings are for the most part not allowed.

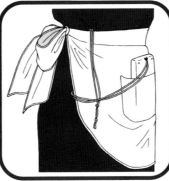

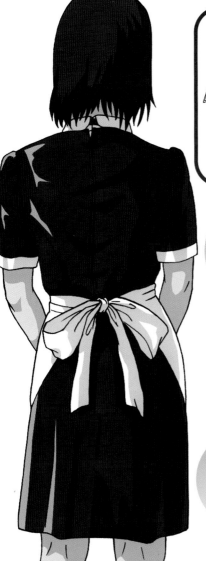

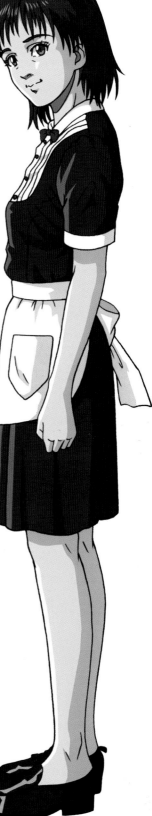

CHECK POINT!

Since this is a steakhouse, the dishes tend to weigh more than those at other restaurants, and carrying them is quite strenuous labor. Orders are taken using an electronic pad, which is kept in the apron's right side pocket.

CHECK POINT!

The dress's skirt falls approximately 5 centimeters (about 2 inches) above the knee. Employees must wear either brown or black leather loafers. Nylons must be flesh-toned.

DETAILS

CHECK POINT!

The dress is made of a synthetic fabric that has a sheen. The garment requires dry cleaning. The tucked sleeve makes the shoulder appear attractively squared, giving the impression of good posture.

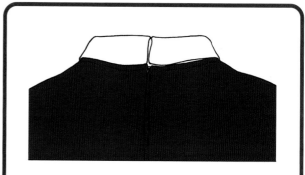

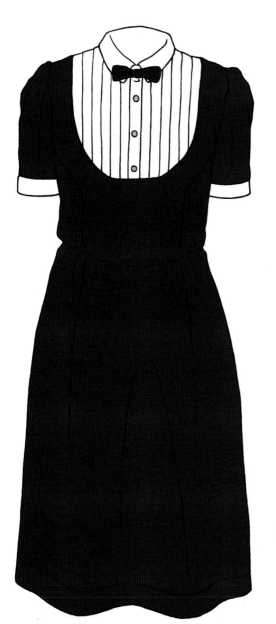

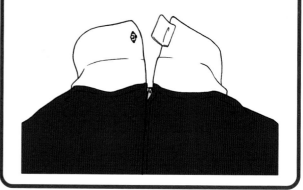

CHECK POINT!

The dress has a Peter Pan collar. Although it does not have a neckband, the collar turns down, thereby causing it to stand up somewhat around the neck. The back is fastened with Velcro.

CHECK POINT!

The dress has a simple A-line, but it includes a yoke with tucks, similar to something an old-fashioned barmaid might wear, giving it a quaint, country appearance. The yoke has four buttons. The bow is adjusted from the back.

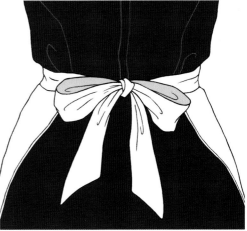

CHECK POINT!

The apron comes in basic white and is rather short. It is fitted with hardly any flare.

SHOP INFORMATION!

Victoria Station
The ambiance of this restaurant is nostalgic, hearkening back to those days when travel by rail was popular in Europe and the United States. Sturdy, leather-upholstered, wood-frame booths face one another just like the compartment benches found on trains way back when. The employees are dressed similarly to the waitresses in the dining cars of the day, and briskly walk back and forth carrying heavy trays, serving the customers with complete courtesy. The juicy, American-style prime rib comes highly recommended.

* Sadly, all of the Victoria Station branches in Japan closed after I finished my research for this book.

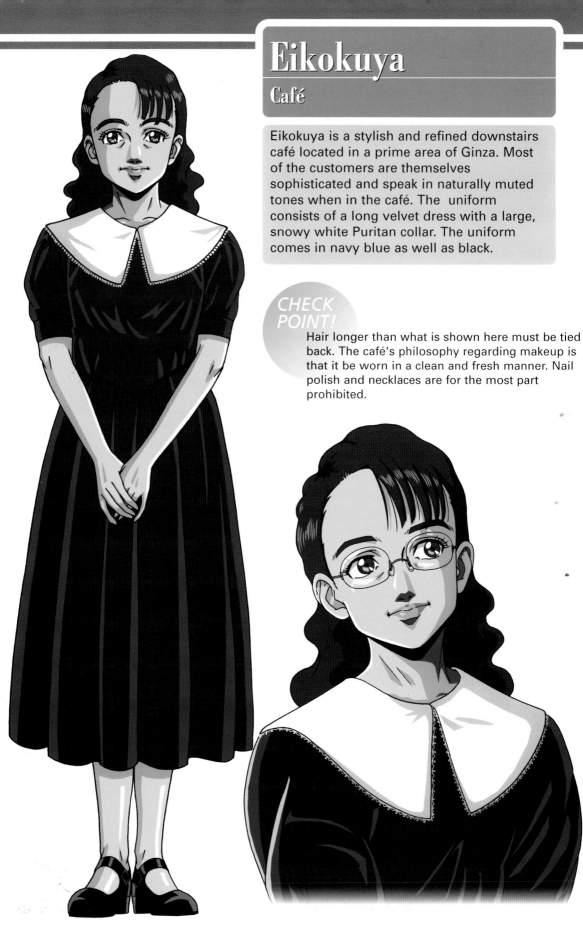

Eikokuya
Café

Eikokuya is a stylish and refined downstairs café located in a prime area of Ginza. Most of the customers are themselves sophisticated and speak in naturally muted tones when in the café. The uniform consists of a long velvet dress with a large, snowy white Puritan collar. The uniform comes in navy blue as well as black.

CHECK POINT!

Hair longer than what is shown here must be tied back. The café's philosophy regarding makeup is that it be worn in a clean and fresh manner. Nail polish and necklaces are for the most part prohibited.

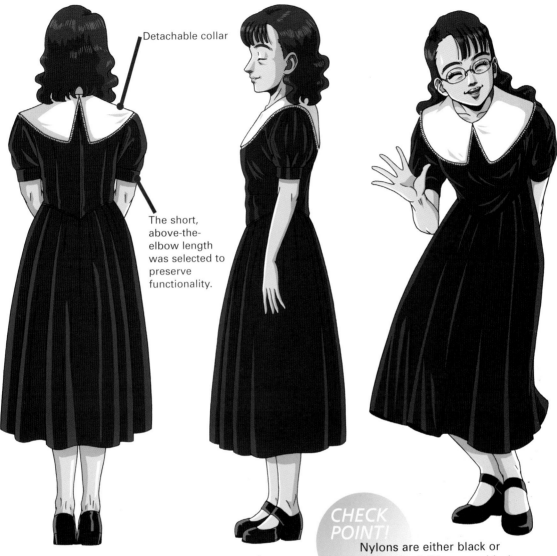

Detachable collar

The short, above-the-elbow length was selected to preserve functionality.

CHECK POINT!
Nylons are either black or flesh-toned. Shoes are black or dark brown loafers.

SHOP INFORMATION!

Eikokuya
Eikokuya is part of the France-ya chain, whose flagship restaurant is in Osaka. The chain also has branches in Kobe and Kyoto. The interior design is tasteful, the menu is tasty. This café projects an extremely tranquil, subdued ambiance. Eikokuya has many regular customers, and the staff is trained to remember their names. The uniform is simple, yet the fabrics are high-quality. Consequently, the uniforms' upkeep is rather expensive.

Contributing Branch: Kissakan Eikokuya
3-7-16 Ginza
Chuo-ku, Tokyo
Tel.: 03-3264-0462
Hours: 8:00 a.m. to 10:30 p.m.
Mondays through Saturdays
8:00 a.m. to 11:00 p.m. Fridays
8:00 a.m. to 10:00 p.m.
Sundays and holidays

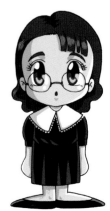

More Great Uniforms
A Famous Patisserie

This uniform is worn by waitresses in a shop specializing in sponge cakes. The shop, which doubles as a café, is quite famous and has been featured on television. A large portion of the shop's business consists of gift sales, and so the employees at the gift counter are extremely polite and pretty. The old-fashioned use of color and design projects a sense of tidiness.

CHECK POINT!

The uniform includes a large head kerchief, which is unusual for floor and counter staff. The kerchief completely covers the hair and is tied at the nape. Some of the employees use a hairpin behind the ears to secure the kerchief in place.

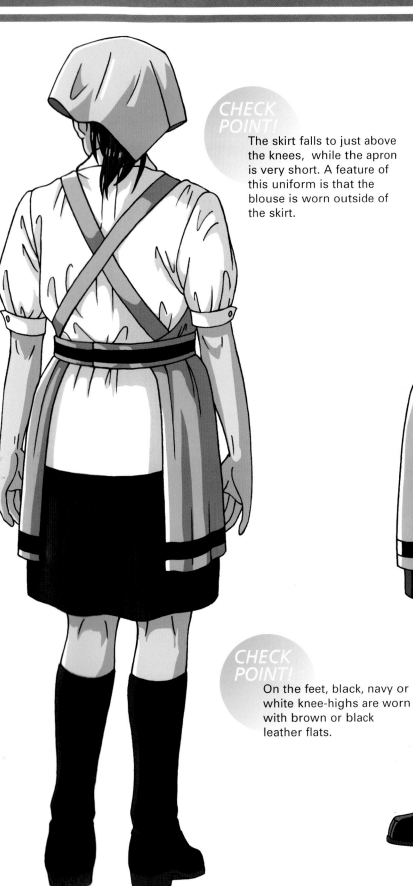

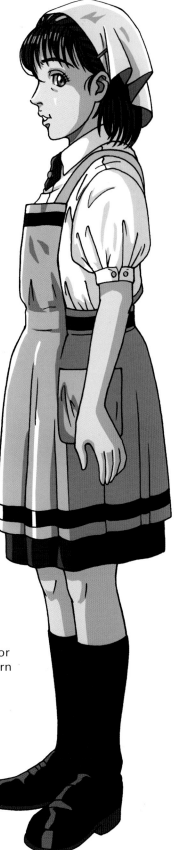

CHECK POINT!

The skirt falls to just above the knees, while the apron is very short. A feature of this uniform is that the blouse is worn outside of the skirt.

CHECK POINT!

On the feet, black, navy or white knee-highs are worn with brown or black leather flats.

DETAILS

CHECK POINT!

The apron consists of three sections: the front and the right and left sides. The green trimming on the bib, waistband and hemline serve as accents.

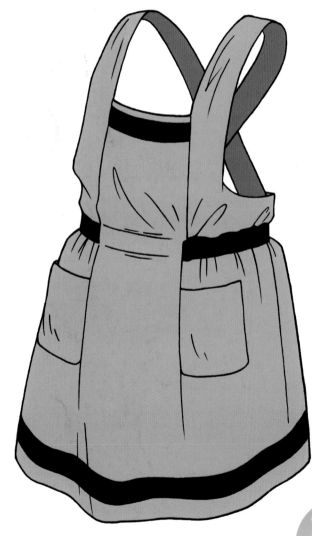

CHECK POINT!

The sleeves are puffed and feature double cuffs. The sleeve is short enough that some of the upper arm is visible.

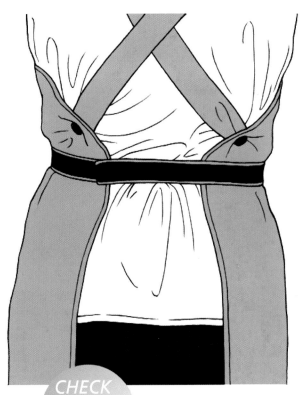

CHECK POINT!

The collar has an open design that allows it to show off the cravat, which is held in place with a tiepin in the center.

CHECK POINT!

The back straps button to the apron's sides rather than to the waistband. The apron is not tied at the waist, but fastened with Velcro, allowing the wearer to adjust the width for a secure fit.

CHECK POINT!

The skirt is straight and ends above the knees. Some of the employees roll up the waistband so the skirt doesn't fall below the knees.

SHOP INFORMATION!

Research for the uniform shown on these pages was conducted at a shop in Nakano, Tokyo. The manager and part-time staff were friendly and cheerful, and the atmosphere was very pleasant. However, the owners did not wish the shop to be mentioned by name in this book, so I have taken liberty in adjusting the uniforms details just a bit.

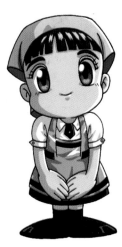

Maid Uniforms

A Close-up Look

I researched several restaurants and cafés whose staff wear maid and boarding school-style uniforms and categorized them as follows:

The Trustworthy Maid

The traditional white, ruffled apron and lace headpiece are absolutely guaranteed to give your character girlish charm. This style of uniform is typically drawn with above-the-elbow sleeves and white cuffs.

The Spinster

This is a simple, long A-line dress. The glasses, laced granny boots and tightly cinched belt paint the picture of a no-nonsense governess.

The Tomboy

The tomboy allows her hair to be blown and tousled, expressing her free spirit. The apron should be functional and for the most part not have ruffles.

The Chaste Maid

This uniform is simple, emphasizing youth and innocent purity. The skirt and apron are short. The bow at the neck is oversized. The Mary Janes make her appear more meek and mousy than would loafers.

The Schoolgirl

This is a boarding school-style uniform. It is simple, yet not monotonous, and is girlish, yet in an understated manner. This uniform looks great when worn by several waitresses working together.

The Little Girl

This uniform is childlike and innocent. The intricate frills were designed to remind the viewer of baby clothing. The oversized headpiece makes the head appear small. The cross tie functions as an accent.

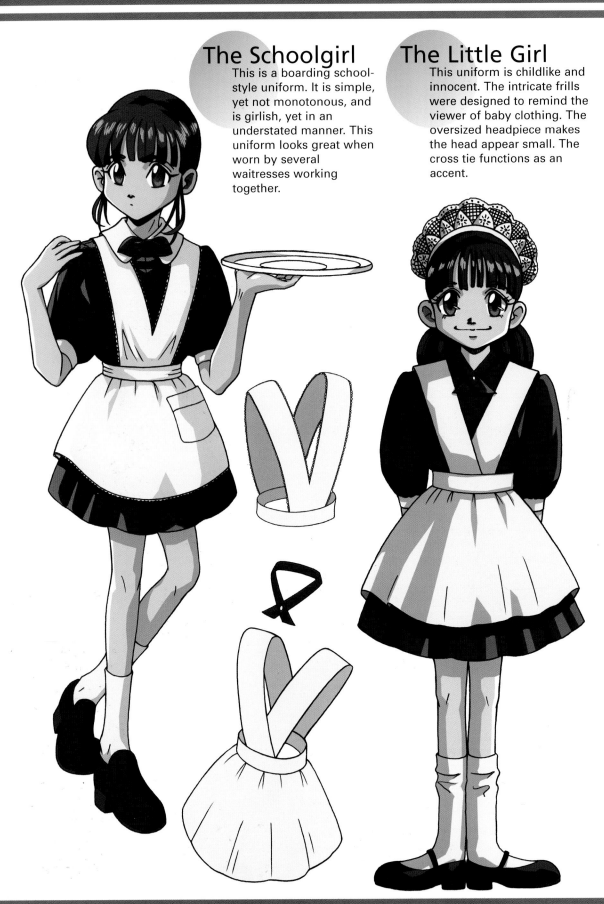

The Posh Maid

This illustration shows a halter-top jumper with a bib that plunges into a deep V. The short-sleeved blouse creates the image of a true hard worker.

The Bookworm

The wing collar, flat club bow tie and straight skirt emphasize trustworthiness. A tuxedo shirt is better suited to this character's image than would a blouse. The deep neckline of the dress adds a touch of allure to the character.

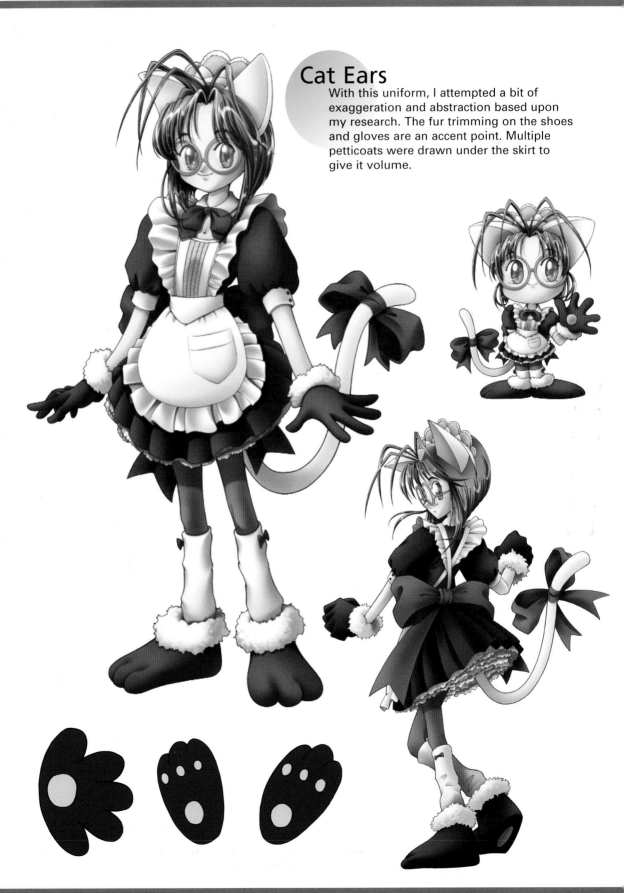

Cat Ears

With this uniform, I attempted a bit of exaggeration and abstraction based upon my research. The fur trimming on the shoes and gloves are an accent point. Multiple petticoats were drawn under the skirt to give it volume.

Nurse Uniforms

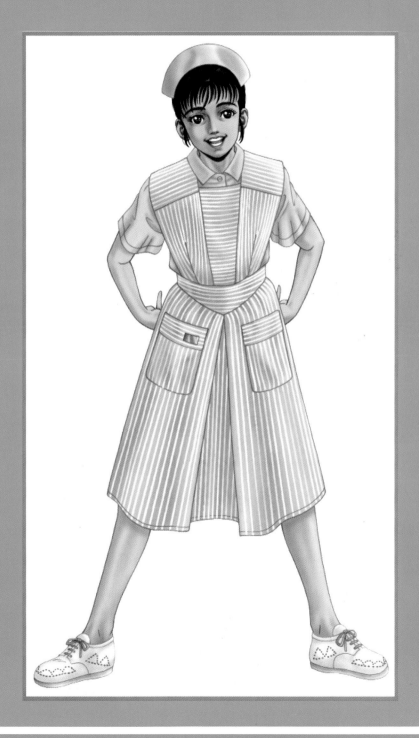

Nurse Uniforms

The nurse is hardly a part-timer, but there are so many attractive nurse uniforms, I included a few for reference. All of the designs appearing on these pages are actual uniforms.

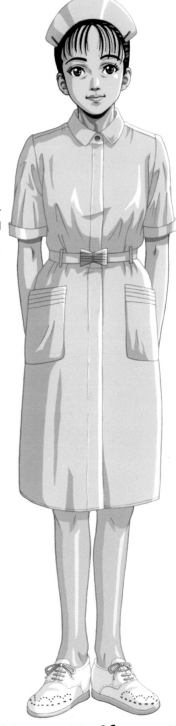

Traditional Nurse Uniform I

This uniform is 85% polyester and 15% cotton with a special antimicrobial agent. The material has static guard, and is perspiration-absorbent and stain-resistant. The white collar is an accent point. This design also comes in all-white.

Traditional Nurse Uniform II

The Japanese fashion design company KANSAI produces this 100% polyester uniform. The price is somewhat higher than that of other uniforms. The material includes a static guard. The bow on the belt serves as an accent. This design also comes in all-white.

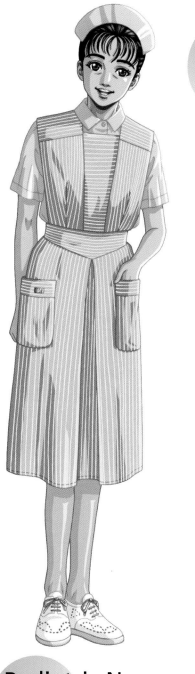

Candy Stripers

This striped apron is of a familiar design, seemingly something your mother might even wear. Candy stripers help feed and bathe patients, so the fabric is made of water-repellant fibers.

Pediatric Nurses

This uniform is the same color as the candy striper's, so it is easy to confuse the two. However, the pediatric nurse uniform consists of a pinafore worn over a blouse. This uniform is made of 80% polyester and comes in medium (98 centimeters, or about 36.5 inches in length) and large (100 centimeters, or about 39 inches long).

Smocks

The somewhat old-fashioned smock is styled similarly to the *kappogi* (Japanese apron). This uniform features a matching collar and cap as well as elasticized sleeves.

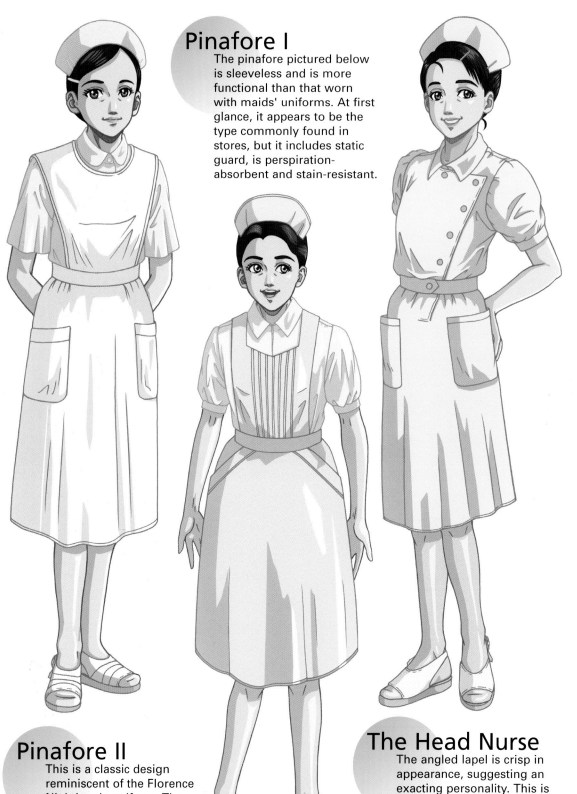

Pinafore I

The pinafore pictured below is sleeveless and is more functional than that worn with maids' uniforms. At first glance, it appears to be the type commonly found in stores, but it includes static guard, is perspiration-absorbent and stain-resistant.

Pinafore II

This is a classic design reminiscent of the Florence Nightingale uniform. The round nurse's cap suggests gentleness. The vinyl shoes contain cushioned innersoles.

The Head Nurse

The angled lapel is crisp in appearance, suggesting an exacting personality. This is another design by KANSAI. This uniform comes in white, blue and pink. The shoes contain cushioned innersoles.

Cardigans

The nurse often wears her cardigan when working
nights or when leaving the hospital on errands. The
fabric is 100% wool and is of high quality, and
includes an antimicrobial agent, and is odor-and-
pilling resistant. The cardigan's color is matched to
the uniform.

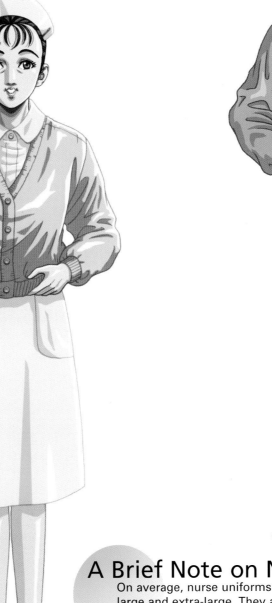

A Brief Note on Nurse Uniforms

On average, nurse uniforms come in four sizes: small, medium,
large and extra-large. They are offered in wide variety of pastel
tones, including pink, peach and blue. The nurse cap comes in
various styles: layered, squared and rounded. Some uniforms
include headpieces. Nurses' stockings are made according to
particular specifications and have an antimicrobial agent. Since
nurses spend considerable time on their feet, their shoes have
cushioned innersoles and built-in support to alleviate bunions.

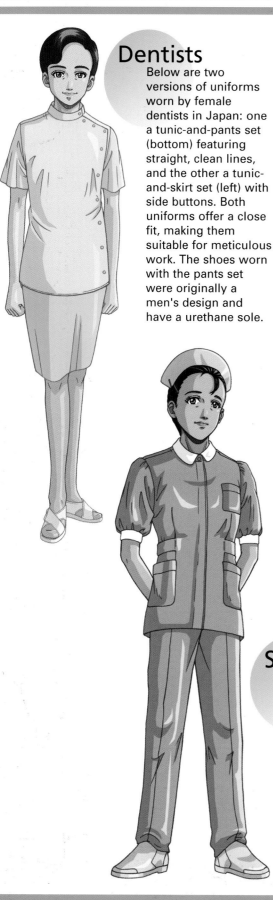

Dentists

Below are two versions of uniforms worn by female dentists in Japan: one a tunic-and-pants set (bottom) featuring straight, clean lines, and the other a tunic-and-skirt set (left) with side buttons. Both uniforms offer a close fit, making them suitable for meticulous work. The shoes worn with the pants set were originally a men's design and have a urethane sole.

Dental Hygienists

This uniform is a tunic-and-pants set. A focal point of the design is the wrap front that fastens to the left. The waist has tucks, causing the tunic to gather slightly about the waist.

Surgical Scrubs

Scrubs consist of a tunic-and-pants set and are treated with an antimicrobial agent and static guard. The garments are made of perspiration-absorbent and stain-resistant fibers. Green is a complementary color of red, functioning to lessen the visual impact of bloodstains on the clothing.

Traditional Japanese Costumes

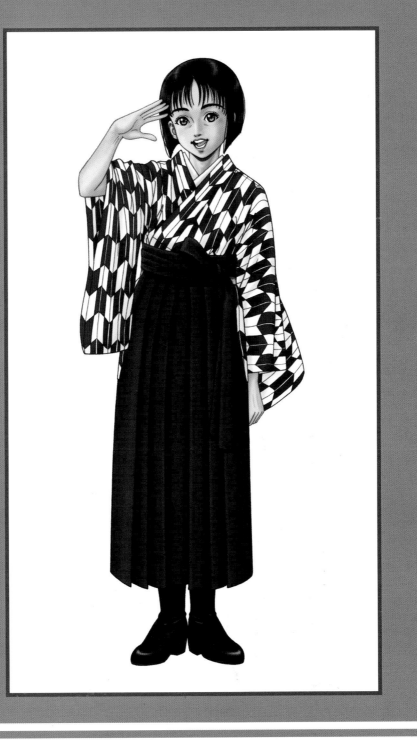

Bashamichi
Restaurant

This adorable costume, which hearkens back to the kimono worn by Japanese schoolgirls during the Meiji (1868-1912) and Taisho (1912-1926) periods, is extremely popular among waitresses at this restaurant. Although the restaurant supplies the granny boots, employees may also purchase the shoes themselves. Consequently, they are able to select and wear their favorite design. Naturally, all of the granny boots are Bashamichi's own brand. The interior is cloaked in a romantically nostalgic ambiance. The menu features pasta dishes.

The *hakama* (pleated skirt worn over a kimono) is tied to the left to free up the right hand, which is generally occupied.

CHECK POINT!
Makeup is worn to project a natural, wholesome appearance. Nail polish of any color, including clear, is prohibited. Accessories are also not permitted.

The *eri* (collar) lies about three-fingers-width from the nape.

CHECK POINT!
Long hair is worn in a bun, covered by a black hairnet. Short hair is worn with the sides pinned to expose the ears.

A kimono secured by an *obi* (sash) is worn underneath, causing the back of the *hakama* to protrude. A towel is wrapped around the waist underneath the *obi* to prevent it from shifting.

CHECK POINT!
The *hakama* comes in two sizes. Each part-time staff member is supplied with one *hakama*. The waitresses wear the same costume year-round. The garments are dry cleaned; however, the employees iron the inner collar and *tasuki* (sash for tying back kimono sleeves) themselves.

DETAILS

The kimono consists of a single layer of fabric. The inner collar is in reality a *date-eri* (detachable collar) that the employees remove and wash themselves.

A swatch of matching cloth has been sewn onto the shoulder to provide protection when the *nafuda* (nametag) is pinned to the kimono and *tasuki*.

CHECK POINT!

The *hakama* became a standardized addition to the Japanese schoolgirl's uniform around Meiji 30 (1897). At the time, maroon (dark reddish-brown) was a popular color for *hakama*, but Bashamichi's *hakama* is a bright purple close to *Edo murasaki* ("Edo purple," a rich purple, Edo being the name of old Tokyo). The *hakama* has a pocket, and an electronic notepad for taking orders is attached to a loop on the waist.

A bow barrette of the same fabric as the *hakama* is worn in the hair.

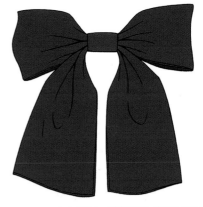

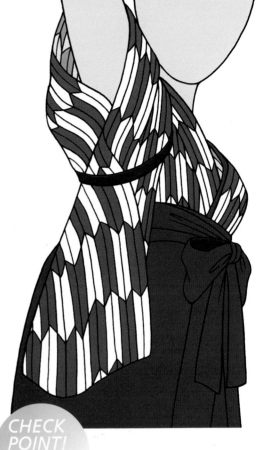

CHECK POINT!

The kimono features the *yabane* pattern worn by the popular manga character Haikarasan of *Haikara-san ga tooru* (roughly, "Here Comes Miss Vogue"). The distinguishing feature of this pattern is the alternating rows of elongated chevrons (each divided by a central line). The illustration on Page 87 shows the standard *yabane* pattern. The kimono also comes in green and blue.

Employees are permitted to wear granny boots they have purchased retail in addition to those supplied by the restaurant. Only flesh-colored nylons are permitted.

CHECK POINT!

The *tasuki* is made of the same material as the *hakama*. Some skill is needed to tie the *tasuki* so that it is neither too tight nor too loose. The *tasuki* appears its most attractive when creases formed on the back of the kimono are pleasingly elongated. The waitresses wear the *tasuki* at all times, not just when washing dishes.

SHOP INFORMATION!

Bashamichi
This chain of restaurants, which hearken back to the Meiji and Taisho periods, has opened several branches throughout Japan. I did my research at the Kashiwa Toyoshiki branch in Chiba Prefecture. Other branches have costumes in different colors, as well as uniforms with white blouses and black full-length aprons. The restaurant trains its employees to "begin and end all service with a bow," which is certainly reflected in their demeanor.

Contributing Branch: Bashamichi, Kashiwa Toyoshiki Branch
1462-3 Shikoda
Kashiwa-shi, Chiba Prefecture
Tel.: 0471-40-1601
Hours: 11:00 a.m. to 2:00 a.m. daily
(Last orders taken at 1:30 a.m.)

Individual Garments
Traditional Japanese Costumes

This section lumps together a wide variety of costumes, from those worn by maids at hot-spring resorts to the garments of waitresses at Japanese-style restaurants to the gowns favored by *miko* (shrine maidens). On these pages, I have included a few attractive designs from among those "traditional" costumes that the Japanese know oh so well.

Nakai (maid at a Japanese-style inn)

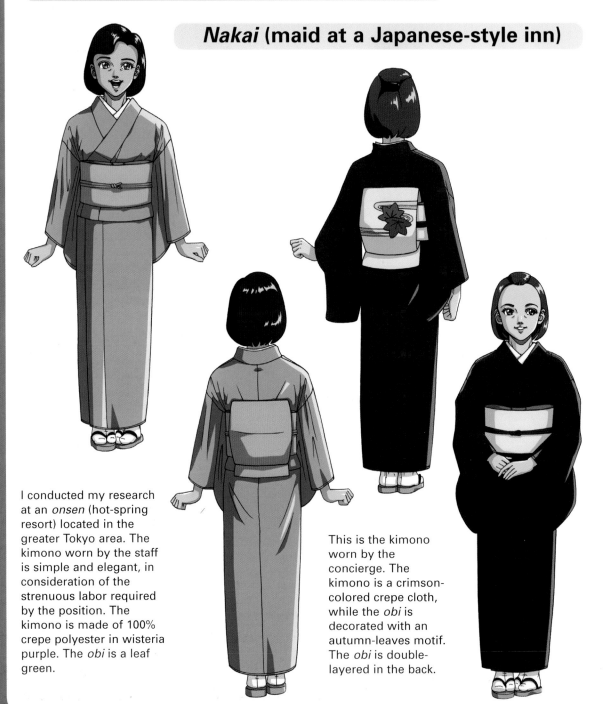

I conducted my research at an *onsen* (hot-spring resort) located in the greater Tokyo area. The kimono worn by the staff is simple and elegant, in consideration of the strenuous labor required by the position. The kimono is made of 100% crepe polyester in wisteria purple. The *obi* is a leaf green.

This is the kimono worn by the concierge. The kimono is a crimson-colored crepe cloth, while the *obi* is decorated with an autumn-leaves motif. The *obi* is double-layered in the back.

Tying the *Obi*

The illustrations on this page demonstrate how to tie the *obi* using the *taiko musubi* (*taiko knot*) favored by *nakai*. This knot can be traced to the rebuilding of Kameido Shrine's Taikobashi Bridge, when *geisha* in the Fukagawa district of Tokyo crossed the rbridge wearing their *obi* knotted in this fashion. The elegant shape shows off the *obi*'s motif.

1
The *obi* is wrapped twice around the torso, and the upper end is laid on the right shoulder.

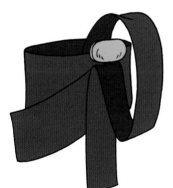

2
The end laid on the shoulder is then brought down over the section wrapped around the torso, wrapped under, pulled up, and set in place with a cord. The dangling end of the *obi* is tucked under the front.

3
An *obi makura* (*obi* pad) is fitted snugly to the small of the back. The size of the *taiko* knot is then determined, and an *obi age* (bustle) is added.

4
A cord is brought under the *taiko* and tied in the front using a simple knot.

5
The *obi* end tucked under the front in Step 2 is drawn through the *taiko* and fixed with an *obi shime* (cinch).

Tabi (split-toe socks) are fastened by hooks at the back.

Dressing in a Kimono

While some of the finer restaurants require that their staff members wear proper kimono, most of the part-timers wear a simplified version. On these pages are presented both the proper kimono and the simplified version.

3
The *eri* is aligned with the *nagajuban* (long under-kimono) underneath, and the desired length determined.

The Proper Kimono

The Simplified Kimono

1
The *tabi* are put on first. Next are donned the *susoyoke* (an underskirt) and *hadajuban* (a short, wrapped undergarment). At this stage, padding is added to the waist.

2
The *eri* is crossed just under the hollow of the neck. A cord called a *munehimo* is wrapped around the torso, followed by a small sash called a *datejime*, which is tied underneath.

3

The first two steps are the same for both the simplified version and with the proper kimono. Those with curvaceous figures often use towels to pad the waist in order to flatten curves, which can destroy the kimono's clean lines.

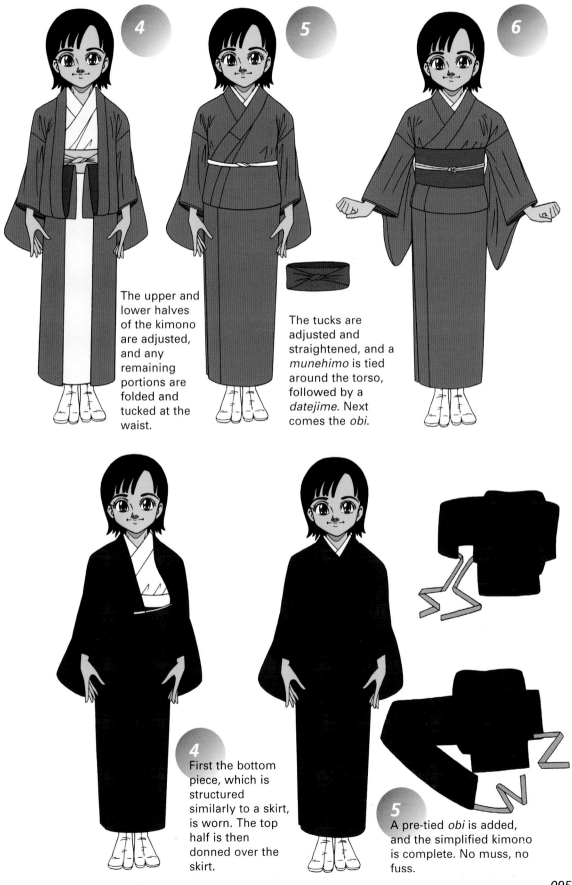

4

The upper and lower halves of the kimono are adjusted, and any remaining portions are folded and tucked at the waist.

5

The tucks are adjusted and straightened, and a *munehimo* is tied around the torso, followed by a *datejime*. Next comes the *obi*.

6

4

First the bottom piece, which is structured similarly to a skirt, is worn. The top half is then donned over the skirt.

5

A pre-tied *obi* is added, and the simplified kimono is complete. No muss, no fuss.

Stylized Japanese Uniforms

Recently, the number of restaurants in Japan offering multiethnic menus has been increasing. Many of these restaurants dress their employees in costumes that combine Japanese styles with those found in other parts of the world. I researched a few of the more characteristic designs.

Japanese Restaurants

This uniform consists of a crimson *chabaori* (a jacket worn when serving tea) and wrap skirt worn under an apron of a slightly lighter tone and a Japanese-style sash. The uniform includes a detachable collar, allowing for frequent laundering.

Sukiyaki and *Shabu-Shabu* Restaurants

This unisex uniform consists of a jacket referred to as a *happi* (livery coat) and pants. The fabric is a broadcloth, printed with a bamboo motif, while the collar follows a *matsukawabishi* (triple-layered diamond) pattern. *Sukiyaki* and *shabu-shabu* are Japanese meat dishes.

Japanese-style Ramen Shops

These are unisex *samu-e* (traditional work clothes of Buddhist monks) made of a polyester-and-cotton blend called "slab oil." The collar is detachable. This uniform is unusual because even the female staff members wear geta (Japanese wooden clogs).

Multiethnic Restaurants

This mustard-colored Japanese-style tunic-and-pants set is made of 100% cotton and can be tossed into the washing machine. The uniform is unisex. The female staff members wear the uniform slightly oversized. An accent point is the toggle loops used in lieu of buttonholes. A bandana is worn around the neck.

Kimono Patterns á la Carte

Other than in a large, traditional Japanese inn, there is no call for ordering matching kimono for the entire staff. For the most part, each establishment keeps on hand a variety of kimono designs and selects a pattern that most suits the particular employee. This page features a number of popular kimono designs that I pulled from a catalog targeted at inns and restaurants.

2 This is a latticework-and-flower-blossom pattern on a celadon-colored fabric. Celadon was a color historically reserved solely for clothing worn by members of the Japanese royal court.

1 This is a vertical waves-and-spray pattern. The pink used in the design is a traditional Japanese color, suggesting the pale pink of a cherry blossom.

4 This is a crimson *kasuri* (tie-dyed, woven yarn) pattern. Crimson is considered a traditional Japanese color.

3 This is a cherry blossom pattern against a solid plum color. The purplish pink of the red plum blossom was a color cherished by the nobility during the Heian Period (794-1192).

Matsuri

Festival Costumes

While this might not be a worker's uniform, what could be cuter than the sight of a young woman wearing a *happi* coat and *nejirihachimaki* (twisted headband)! The following pages show the dress worn at *matsuri* (festivals) in Tokyo and *awa odori* (dances traditionally performed at summer festivals).

CHECK POINT!

The stylish festival-goer wears her hair pulled back in a bun. The *hachimaki* (headband) is held secure with hairpins. No undergarments are worn. Instead, a bleached-white cloth is wrapped around the torso so that it directly touches the skin. The cloth is wrapped so tightly it is almost constrictive.

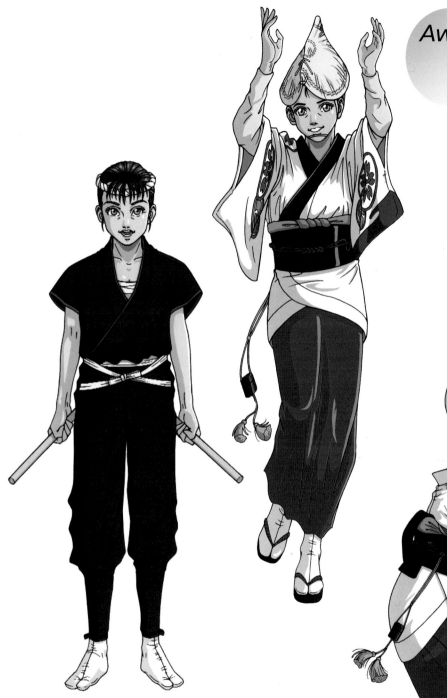

Awa Odori

Although Tokushima is home to the *awa odori*, the costumes I present here are those worn when the dance is performed in Tokyo and Koenji. While the sight of women clad in kimono dancing is alluring, the restrictive kimono makes dancing for such an extended period of time an arduous feat. For this costume, a long-sleeved undershirt is worn under the *happi*, and a red *nagajuban* is worn for the skirt. *Geta* are worn instead of *zori* (straw sandals).

Odaiko

This costume consists of a *samu-e* with a bleached-white cloth worn underneath. A *nejirihachimaki* tops off the hearty, dynamic image of the *odaiko* drummer. The lower halves of the pants fit snugly around the calves, giving the appearance of wearing gaiters. The soles of the *tabi* are stiff like that of *zori* and can be worn outdoors without sandals.

Miko

Shrine Maiden Attire

Originally, a *miko* was a maiden engaged in the service of the gods and spirits. *Miko* would perform *kagura* ceremonial dancing and would communicate with the spirits to learn their will, giving rise to the *miko*'s alternate appellation of *kannagi* (spirit child). Today, the young women we see dressed in *miko* attire during the New Year's holiday period work at the shrines part-time, selling good-luck charms and acting as guides to the shrine compound. The dress worn by the *miko* is somewhat complex, with one full costume said to cost at least ¥60,000 (more than $500).

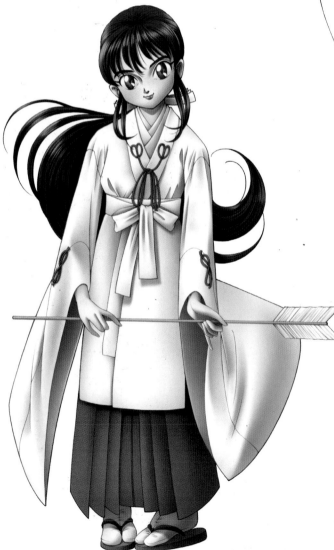

A decorative braided red cord is sewn to the costume's collar. This cord has appeared on *miko* dress continually since the Heian Period.

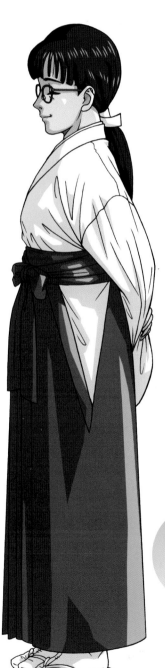

The hair is worn back, tied low on the nape. The hair is never worn up. Occasionally, the hair is wrapped with a reversible strip of paper, red on the inside and white on the out, but solid white is more common.

White *tabi* are worn with *zori*. The thong of the *zori* is also white.

The *hakama* worn by *miko* is called a *hibakama* (red *hakama*), which is a simplified version of the *nagabakama* (long *hakama*) favored during the Heian Period. Also known as the *kiri-bakama* (literally, "cut" *hakama*), this garment ends just below the ankles.

This illustration shows a *miko* wearing a *chihaya* (light outer robe). The see-through versions sold at costume shops are usually imitations. Authentic *chihaya*, however, are made of silk, making them smooth and sheer, but not to the point of being translucent. Modesty and purity tend to be qualities emphasized in the design of clothing worn by those in the service of the gods.

Decorative cords are occasionally sewn to the *chihaya*. The one shown here is in a loose figure-eight knot.

The *chihaya*'s sleeves are exceptionally long, and the front panels of the robe cross just under the breast. The cord sewn to the *eri* is decorative. Some *chihaya* have no such adornment. The cord is looped in a butterfly-shaped tape knot and its length adjusted accordingly.

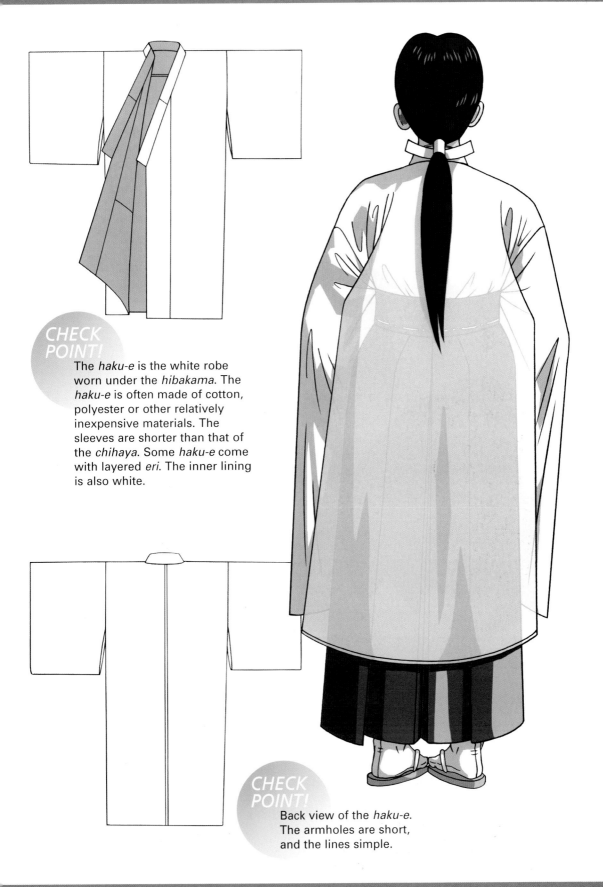

CHECK POINT!

The *haku-e* is the white robe worn under the *hibakama*. The *haku-e* is often made of cotton, polyester or other relatively inexpensive materials. The sleeves are shorter than that of the *chihaya*. Some *haku-e* come with layered *eri*. The inner lining is also white.

CHECK POINT!

Back view of the *haku-e*. The armholes are short, and the lines simple.

A sash is sewn to the waist of both the front and the back of the *hakama*. The front sash is wrapped twice around the waist and tied in the back. The back of the *hakama* (called the *hakama koshi*) is then used to cover the back knot, as the sash attached to the *hakama koshi* is brought around and tied in the front.

The *hibakama* was part of the daytime dress worn by Heian Period nobility, who would change into different robes for their evening social dress. Antique illustrations of *kemari* (Japanese kickball) matches show players in such daytime dress. The *hibakama* is a kind of a *hakama*, but it is actually constructed similarly to a skirt rather than the true *hakama*, which is more reminiscent of culottes. Both the front and the back of the *hibakama* are pleated and the front is divided into two pieces.

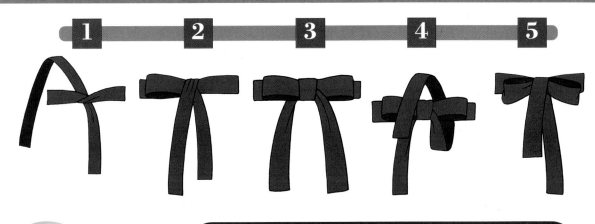

CHECK POINT!

The end of the sash is brought over once again to cover the knot. Concealment of knots is a common feature of traditional Japanese dress. A decorative cord is woven into the *hakama*'s waist.

CHECK POINT!

There are a variety of ways a *miko* might wear her robes. Try a few designs that suit a character of your own creation. Always remember the key details.

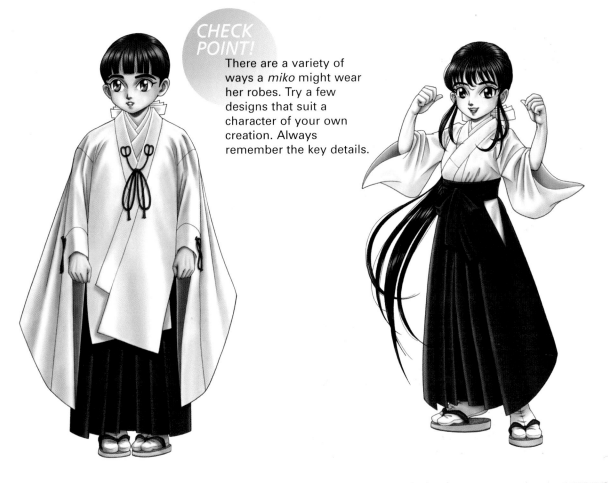

Kimono-clad Hostesses
Key Points in Restaurant Kimono

This is the style of dress worn by the *jyokyu-san*, an expression which today has become derogatory, much like the English word "wench." Consequently, it is a term I do not like to use. However, during the Meiji Period, the term referred to women who served customers in Western-style restaurants, bars and cafés. From the Taisho Period onward, such women more and more took on the role of what has become the modern Japanese "hostess."

CHECK POINT!

Drawing both an apron and *tasuki* (sash for tying back the sleeves) might make the resulting image overly busy. It is perfectly acceptable to draw the kimono sleeves down.

CHECK POINT!

The *obi* is worn in a simple *taiko musubi*, since the apron's straps would become entangled with a more complicated bow. Refer to Page 93 for more information on the *taiko musubi*.

CHECK POINT!

Just adding a Western-style apron helps evoke the romantic mood of the Meiji Period. A key design element is that the apron is longer than that typically found in a maid's uniform.

Office Uniforms

Office Uniforms
Assorted Styles

Lately, more and more attractive office uniforms have been appearing on the scene. A combination of a blouse, straight skirt and button-down vest seem to be the standard. Office workers take in the waist and shorten the hem to make their uniforms even more appealing.

Open-House Realtor

A blouse with a long point collar cuts a smart image. The buttons are color-coordinated with the vest. A short slit in the back of the vest allows for freedom of movement, such as when bending over to pick up an object. The skirt includes pockets. The colorful tie functions as an accent.

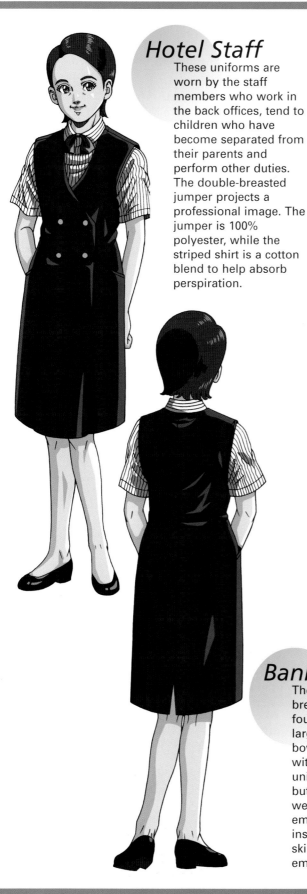

Hotel Staff

These uniforms are worn by the staff members who work in the back offices, tend to children who have become separated from their parents and perform other duties. The double-breasted jumper projects a professional image. The jumper is 100% polyester, while the striped shirt is a cotton blend to help absorb perspiration.

Bank Tellers

The form-fitted, double-breasted vest comes in four sizes: small, medium, large and extra-large. The bow is a clip-on fastened with a safety pin. The uniform cuts a cute image, but understates the wearer's femininity to emphasize seriousness instead. The straight, black skirt is purchased by the employee.

Stationery Store Clerks

This is a somewhat old-fashioned uniform and just seems to be asking for a sleevelet. While some stationery store uniforms come in quite vibrant colors, those depicted here seem to be the most common. The blouse's collar is detachable and is 100% polyester.

Showroom Staff

This is type of uniform worn not by salespersons, but by the administrative office staff. The long, roomy sleeves and necktie (serving as a color accent) project the same reserved, dignified air common to British fashions. The neckband-less Peter Pan collar emphasizes the wearer's femininity.

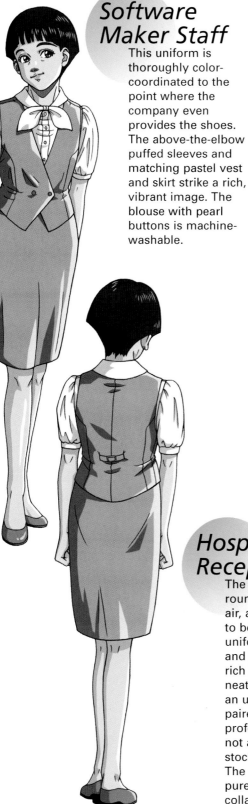

Software Maker Staff

This uniform is thoroughly color-coordinated to the point where the company even provides the shoes. The above-the-elbow puffed sleeves and matching pastel vest and skirt strike a rich, vibrant image. The blouse with pearl buttons is machine-washable.

Hospital Receptionists

The puffed sleeves and flat, round collar create a gentle air, and consequently seem to be common features of uniforms worn by nursing and health-care staff. The rich blue projects a clean, neat image. The shorts are an unusual addition, but paired with the vest, cut a professional image that is not at all casual. The stockings are flesh tone. The vest's pockets are purely decorative. The collar emphasizes the wearer's femininity.

Pumps and Heels

Shoes are usually not provided along with the rest of the uniform, and the employee is required to purchase them herself. Black and brown pumps are the most popular, yet a visit to the stores shows there are many different styles. Here are a few examples.

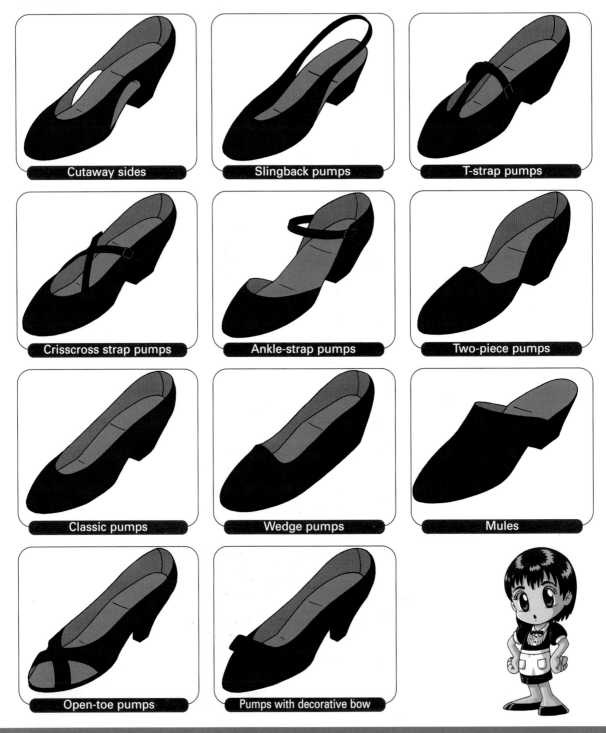

Cutaway sides

Slingback pumps

T-strap pumps

Crisscross strap pumps

Ankle-strap pumps

Two-piece pumps

Classic pumps

Wedge pumps

Mules

Open-toe pumps

Pumps with decorative bow

Exotic Costumes

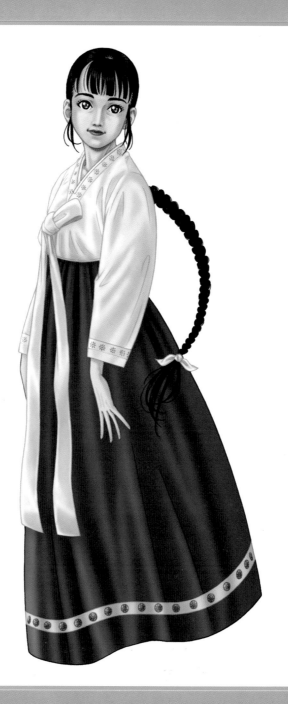

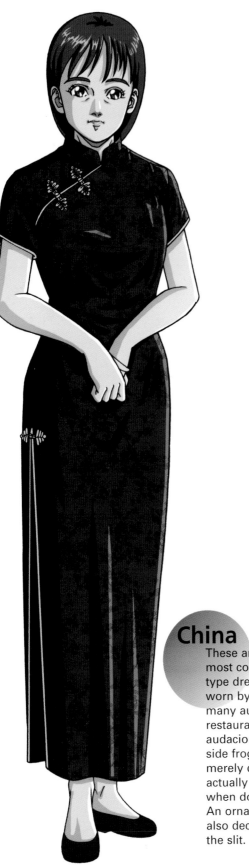

Exotic Costumes
Uniforms Based on National Dress

Tokyo now boasts a host of international restaurants, from Chinese to Thai, Italian, Mexican and Mongolian. The staff uniforms reflect the national dress of the country whose cuisine is being served, and one can see the costumes of the world without ever leaving Japan.

China

These are two styles of the most common Chinese-type dress. The dresses worn by waitresses at many authentic Chinese restaurants often sport audaciously high slits. The side frog toggles are not merely decorative, but actually open and are used when donning the dress. An ornamental frog toggle also decorates the top of the slit.

The sleeves of this dress fall just above the elbow and are a bit longer than those on the dress seen on the preceding page.

The front toggles continue to just below the hips.

CHECK POINT!

This style has a front closure, making it easy to wear. The color, popular in Chinese garments, presents a healthy, dynamic image. The restaurant also provides the apron.

CHECK POINT!

In this version, the blouse and skirt are separate pieces. The skirt, which has a short slit on each side, is straight and has a rear closure.

This is a two-piece set with a long skirt. The imitation silk fabric shimmers whenever the wearer moves.

The sides of the blouse are so perfectly form fitted that they almost appear constrictive. The toggles come off easily, so care must be taken when wearing this uniform.

The blouse has side slits, allowing the wearer freedom in movement.

The braided cord tops off the slit. In principle, this should be the same color as the front toggles.

Ideally, the shoes should be pumps; however, some employees at Chinese restaurants wear athletic shoes on the job instead.

CHECK POINT!

This uniform features a blouse in a red favored by Chinese restaurants, and has coordinated leggings. The piping on the blouse serves as an accent.

Padded shoulders

The blouse is fitted, and the lapel is not turned down. Opening the frog toggles causes the blouse to fall open in a triangle from the neck, exposing the entire right side.

The leggings are made of an elastic fabric and lack snaps, buttons and zippers. The exposed ankles constitute a fashion point.

CHECK POINT!

This is a unusual uniform, inspired by the sort of attire associated with Mao. This design, made of a polyester and cotton blend, is unisex and is worn with leather flats.

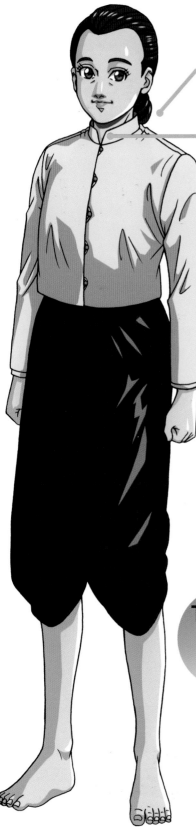

In Thailand, the hair is often worn in a bun held in place with a comb. Here, a barrette is used instead.

This is a color popular among the Chinese as well, perhaps suggesting a cultural influence.

This shows the traditional short jacket and loincloth worn in the chong-kraben style. The cloth is wrapped around the waist, the length then adjusted, brought back through the legs, and tucked into the back of the waist. A safety pin is used to keep it in place. The chong-kraben is highly functional and was originally worn by both men and women, but is now only worn when performing traditional dances or by the elderly.

Thailand

The uniform shown here is that worn by the female staff at a Thai restaurant. The costume consists of the traditional Thai jacket, called an *aingyi*, and a *chong-kraben* cloth typically worn by men to cover the lower half of the body. The jacket is made of nylon. The loincloth is a thin, almost sheer fabric. Straw sandals are worn without nylons or socks.

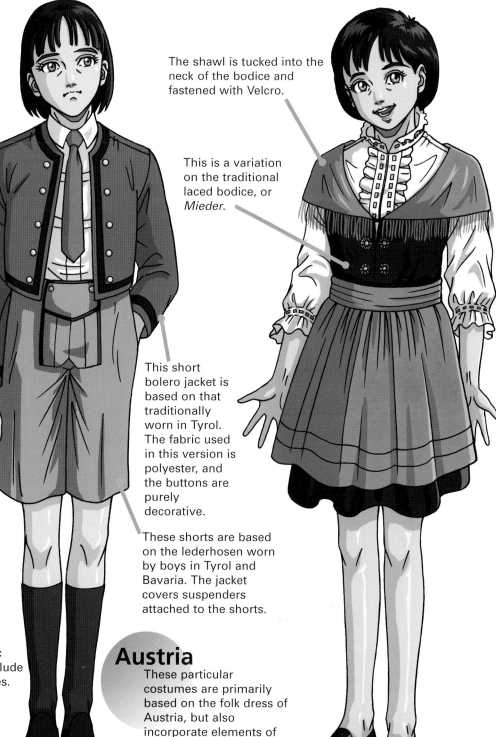

The shawl is tucked into the neck of the bodice and fastened with Velcro.

This is a variation on the traditional laced bodice, or *Mieder*.

This short bolero jacket is based on that traditionally worn in Tyrol. The fabric used in this version is polyester, and the buttons are purely decorative.

These shorts are based on the lederhosen worn by boys in Tyrol and Bavaria. The jacket covers suspenders attached to the shorts.

The authentic costumes include wooden shoes.

Austria

These particular costumes are primarily based on the folk dress of Austria, but also incorporate elements of the folk dress of Italy and Switzerland. There was intermingling in the traditional clothing of the region, resulting in these absolutely adorable combinations.

Thailand

Below is a costume worn at a restaurant serving dishes of the Royal Court, and is inspired by the formal dress favored by affluent young women. The outfit consists of a long-sleeved, tailored blouse called a *sua*, a wrapped skirt called a *pha sin*, and a sash worn across the shoulder and breast.

The cotton shirt is fastened with ties in lieu of buttons or toggles.

The sash is made of a white, sheer nylon. The sash is gathered and held in place with a brooch. Custom dictates that the sash be worn over the left shoulder.

The authentic version is made of Thai silk. However, the restaurant uniform shown here is made of a synthetic silken fabric. The closely fitted sleeves and the color, also used frequently in Chinese fabrics, are distinguishing characteristics. The bodice of the blouse is made of a single cloth with no lining, so it fits snugly to the body.

The pha sin, which has no slit, closely hugs the legs. Having a simple structure, the pha sin is worn by wrapping the skirt around like a tube and then cinching the extra portions of cloth around the waist with a sash.

Indonesia

The uniform on the right is a combination of a wrapped skirt called a *sarong* and an Indonesian-style shirt worn in everyday dress. The sarong is actually a large piece of cloth, sometimes measuring up to 180 centimeters (about 6 feet long). The *sarong* is gathered at the left hip and fastened in place with a safety pin.

Korea

The recognizable *hanbok*, consisting of the *ch'ima* (skirt) and *choguri* (bolero blouse), is traditional Korean formal wear. Normally, the *hanbok* is made of a lightweight silk. However, the costume here is made of polyester.

Myanmar

Consisting of the *aingyi* (top) and a wrap skirt called a *longyi*, this costume forms the modern work clothes of the laborer in Myanmar.

The white collar is detachable to allow it to be removed for laundering.

This is a modified version of the authentic *hanbok*, which would contain a cotton lining. The restaurant uniform version shown here is simplified. The *choguri* is short, not even extending to the navel.

The *ch'ima* is made of a large fabric, occasionally measuring up to 3 meters (nearly 10 feet). The *ch'ima* is worn suspended from straps as the shoulders. A petticoat called a *sok ch'ima* is worn under the skirt, giving it fullness.

The feet are not visible.

More Great Uniforms

I conducted a bit of research on other interesting uniforms around town. These are probably standard products sold by garment distributors, but the combination and other touches make these uniforms look just terrific.

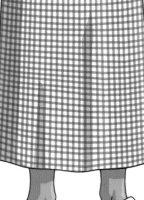

Drive-Through Restaurant

To the left is a sporty combination featuring wrap culottes and a shirt. The unisex shirt is made of a cotton-and-polyester blend. A long-sleeved version is also available. The culottes also come in rose and navy. The waistband has elasticized sides, allowing for ease of movement.

Flower Shop

This is a great uniform I saw on a women working at a flower shop. The gingham check apron has straps that crisscross in the back. Male employees of this shop wear a matching long apron. The unisex shirt is made of a comfortable knit. The employees are allowed to arrange the bandana worn around the neck as they like.

Newly Refurbished Ramen Shop

This uniform consists of *samu-e* pants, a vest and a shirt. The shirt is made of 100% polyester and requires no ironing. The uniform also comes with an apron for food preparation.

Takoyaki (Octopus Dumplings) Stand

This uniform features a Japanese-style cap, a Southeast Asian-style jacket and Hindi-style pants. The pants gather at the ankles, causing the pant leg to bunch up. Consequently the pants will still appear to fit, even if they are actually a little long. The waist has a drawstring; however, the elasticized waistband keeps it from loosening.

Souvenir Shop

This uniform consists of a *jinbe-e* jacket and Japanese-style pants. The *Tosa tsumugi* (a silk textile) weave contains some cotton, and is quite comfortable. The waistband of the pants is elasticized, making them easy to wear. The pant legs have drawstrings, which are tied when the pants are worn.

Multiethnic Restaurant

This is a Japanese-influenced unisex top-and-bottom set. The tunic's sleeves fall just below the elbows. The tunic has slits on either side. The pants have pockets.

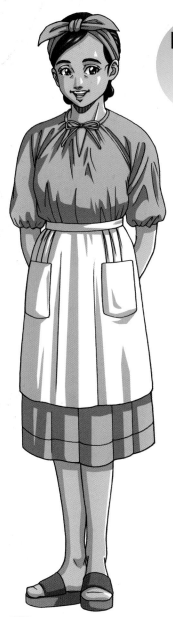

Beer Hall

The uniform below consists of a jumper plus a puffed-sleeve blouse. The kerchief conveniently includes ties, making it difficult to become undone. The jumper's straps crisscross in the back. The waistband is elasticized on either side, allowing for a close fit at the waist.

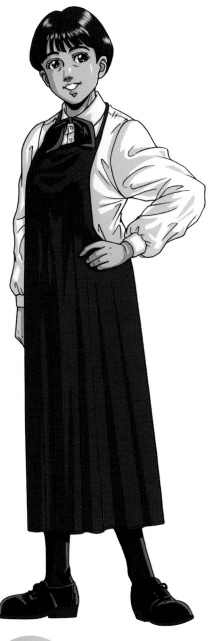

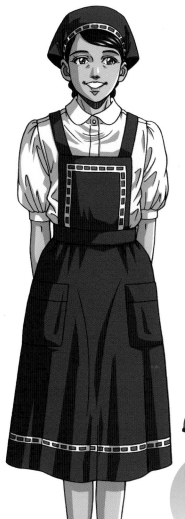

Bakery

The above ensemble, consisting of a 100% cotton snowy white apron, blouse and skirt, is unpretentious and attractive. The blouse, which is slipped on over the head, has elasticized armbands. The skirt is not belted but has an elasticized waistband. The large kerchief comes in one size and can be worn around the neck or in any manner desired.

Grocery Store

Above is a jumper-and-blouse combination. The fabric's dye bleeds, so the uniform requires dry cleaning. The back of the waistband is elasticized, and the bow tie is a clip-on, fastened with a safety pin.

Seductive Costumes

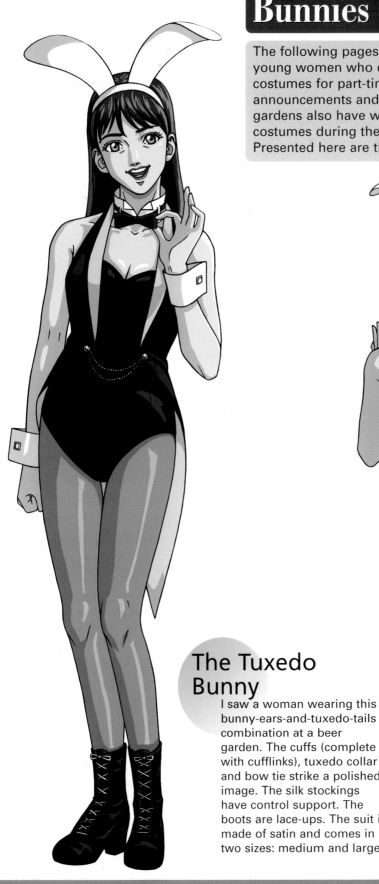

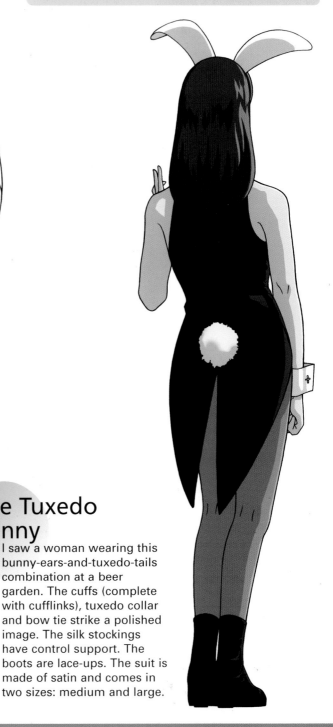

Bunnies

The following pages are dedicated to those young women who dress in bunny costumes for part-time jobs at new-product announcements and similar events. Beer gardens also have waitresses wear bunny costumes during the warmer months. Presented here are three variations.

The Tuxedo Bunny

I saw a woman wearing this bunny-ears-and-tuxedo-tails combination at a beer garden. The cuffs (complete with cufflinks), tuxedo collar and bow tie strike a polished image. The silk stockings have control support. The boots are lace-ups. The suit is made of satin and comes in two sizes: medium and large.

Cat Costume

This novelty costume was being worn by a young woman at a new-product promotion. The costume is recognizable as a cat owing to the ears attached to a headpiece, a bell hung around the neck, and the fluffy white fur. The furry wristbands are elasticized. The costume has a rear zipper closure. The tail has a wire frame to maintain its shape.

Red Bunny

This red bunny costume tickles the fancy of fetishists. The red costume paired with black fishnets creates a striking color contrast. The slit runs rather high. Pumps are more effective than boots with this costume.

Bartenders

Female bartenders have been recently growing in number in Japan. They are superb with shakers, and there are even some female bartenders with a fan base. A tidy appearance is essential to having a relaxed demeanor and to creating a comfortable atmosphere. The uniform is of a design originally intended for men, but restyled to better suit the soft gentleness of a woman.

The wing collar and bow tie are ever-present in bartender uniforms.

Both the shirt and vest have buttons on the left side (common to women's apparel) as opposed to on the right.

A double-breasted vest creates a more dressy appearance than a single-breasted vest.

Black side panels are visually more pleasing.

CHECK POINT!

The smaller illustrations show two types of bartender vests. The cross tie, a key element of the one to the left, emphasizes the wearer's femininity. The one above features a ruffled blouse with a brooch. While this has less of a tailored look than traditional bartender apparel, those seeking to emphasize soft femininity and a more refined appearance are encouraged to dress their character in this style.

Campaign Girls

The so-called "campaign girls" and "race queens" engaged in promoting new products and auto and motorcyle races are both beautiful and in great physical shape. Many of the costumes these women wear are on the scanty side, but these women look terrific in their outfits. Included on the following pages are various characteristics of such costumes.

CHECK POINT!

This is a slightly conservative costume featuring a bolero jacket. The skirt's slit runs rather high, but the yellow-and-white combination takes off some of the edge. (Red-and-black would be overdoing it.) The shape of the bangles and cut of the dress are attractive, striking a sexy, physically fit image. This is the quintessential example of a design where the company's colors are made fully prominent, and yet the costume is still appealing.

CHECK POINT!

This costume features red trim made of a high-gloss material that immediately draws attention. The use of a strong color around the body's contours has a slimming effect. The teardrop shape below the collar is not too big, adding just the right touch. The slits are low and relatively modest.

CHECK POINT!

Below is the ever-popular, swimsuit-inspired design. This particular outfit demonstrates an interesting use of the horizontal and vertical. Diverging from the basic two-piece, this design offers a partial glimpse of the stomach that is both teasing and tantalizing.

CHECK POINT!

The uniform above is an uncommon combination of platform boots and hot pants. The visual flow of the design is highly structured and well suited to women with short hair. The halter-top has a side closure.

CHECK POINT!

The style above announces the corporation's name at a single glance and successfully projects the image of the product, which is a health drink. The costume's color is changed according to the type of drink that is being promoted.

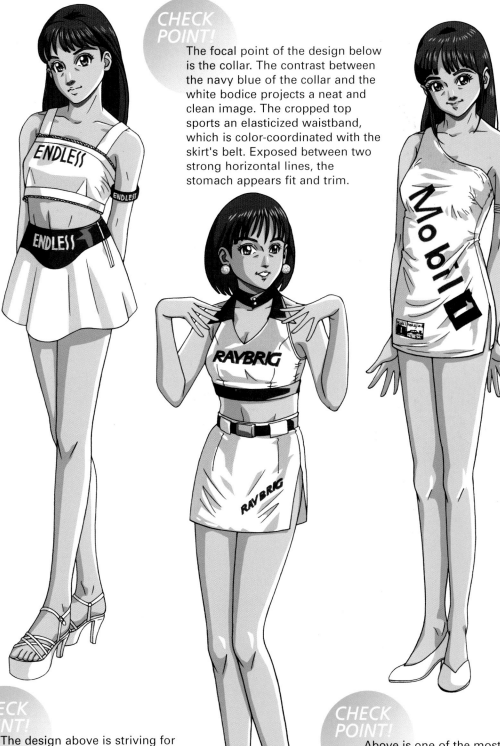

CHECK POINT!

The focal point of the design below is the collar. The contrast between the navy blue of the collar and the white bodice projects a neat and clean image. The cropped top sports an elasticized waistband, which is color-coordinated with the skirt's belt. Exposed between two strong horizontal lines, the stomach appears fit and trim.

CHECK POINT!

The design above is striving for a sweet and innocent image. The tiny frills around the camisole's bodice add a touch of cuteness. The skirt is flared and without slits. The camisole is decorated in the back with a bow made of a sheer fabric. The skirt has a side closure.

CHECK POINT!

Above is one of the most popular designs used for race queen costumes. A car race without young women dressed like this just isn't the same. Incidentally, the design is supposed to be reminiscent of an oilcan.

More Great Uniforms

Here are a few more of the fantastic uniforms I found around town. For these fun finds, I actually had to go snooping into the establishments. Feel free to use them as reference in your own sketches.

Hotel Café

With the apron, white collar, and red satin cross tie, the adorable uniform to the left projects an image of energetic diligence that one associates with domestic servants. The white embroidery on the apron adds a sense of quality and refinement. A belted dress is worn underneath the apron.

Italian Restaurant

The shirt is a linen blend, so the fabric breathes well, and it presents a clean, tailored image. The unisex uniform is made of a 100% polyester gabardine twill. The apron comes in one size. Waiting on tables, which involves the carrying of large plates and other heavy objects, is more labor-intensive than one might think, and functionality was taken into consideration for this design.

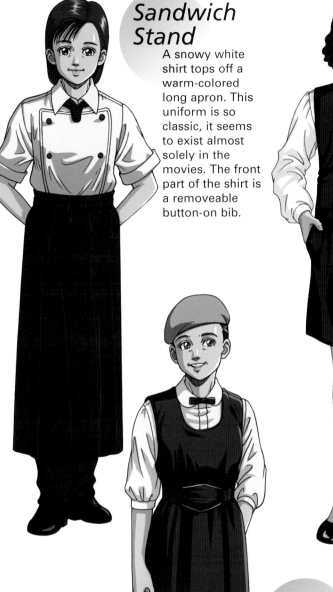

Sandwich Stand

A snowy white shirt tops off a warm-colored long apron. This uniform is so classic, it seems to exist almost solely in the movies. The front part of the shirt is a removeable button-on bib.

Import Shop

The vest, which opens in the front, is adjusted using a buckle in the back. Here, the vest has been adjusted for more roominess. The red frog toggles and mandarin collar give the uniform an exotic look. The culottes, which are made of 100% cotton and can be machine-washed, have a comfortable fit.

Event Hall

This is a uniform worn by guides employed at an event hall. The beret adds a charming touch. The gray jumper has a rear zipper closure.

Beauty Parlor

This is a combination of women's dress trousers with suspenders and a large, white collared blouse. The trousers have a front-fly closure. The suspenders are detachable, and some of the staff members wear their uniforms without them.

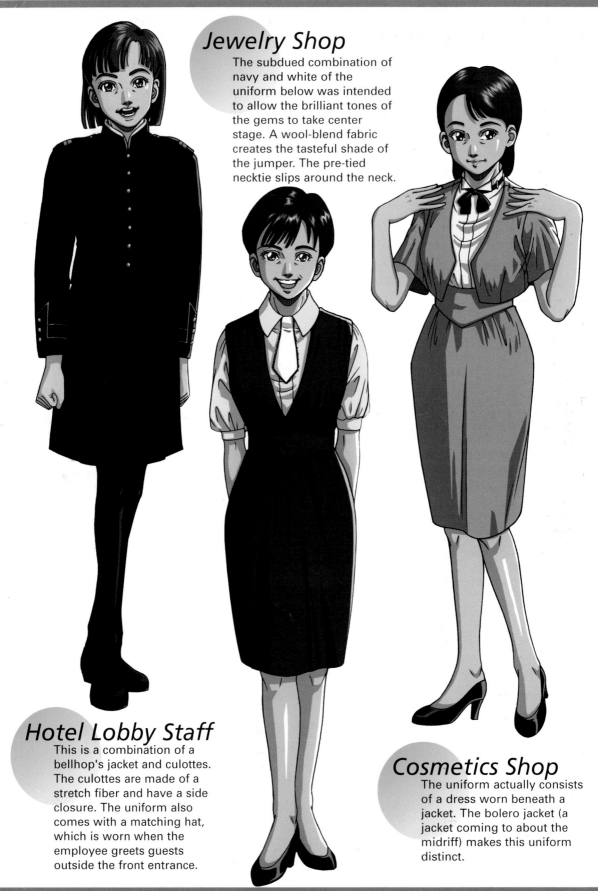

Jewelry Shop

The subdued combination of navy and white of the uniform below was intended to allow the brilliant tones of the gems to take center stage. A wool-blend fabric creates the tasteful shade of the jumper. The pre-tied necktie slips around the neck.

Hotel Lobby Staff

This is a combination of a bellhop's jacket and culottes. The culottes are made of a stretch fiber and have a side closure. The uniform also comes with a matching hat, which is worn when the employee greets guests outside the front entrance.

Cosmetics Shop

The uniform actually consists of a dress worn beneath a jacket. The bolero jacket (a jacket coming to about the midriff) makes this uniform distinct.

La Marée de Chaya,
Hayama Branch (Flagship Restaurant) p. 8
20-1 Horiuchi Hayama-machi,
Miura-gun, Kanagawa Prefecture
Tel.: 0468-75-5346
Hours: 10:00 a.m. to 9:00 p.m. daily

Vie de France, Asagaya Branch p. 12
3-58-1 Asagaya Minami, Suginami-ku, Tokyo
Tel.: 03-3223-6500
Hours: 7:30 a.m. to 8:00 p.m. daily

First Kitchen, Shinjuku, South Exit Branch p. 16
1-18-3 Nishi-Shinjuku, Murakami Bldg., 1st Floor,
Shinjuku-ku, Tokyo
Tel.: 03-3348-5389
Hours: 5:00 a.m. to 2:00 a.m. Mondays
 4:00 a.m. to 2:00 a.m. Tuesdays through Fridays
 3:00 a.m. to 2:00 a.m. Saturdays and days
 preceding holidays
 3:00 a.m. to 1:00 a.m. Sundays
First Kitchen's Official Website:
http://www.first-kitchen.co.jp/

Hediard, Haneda Airport Branch p. 30
3-3-2 Haneda Airport, Ota-ku, Tokyo
Tel.: 03-5757-9292
Hours: 7:00 a.m. to 8:00 p.m. daily
(Last orders taken at 7:30 p.m.)

Twinings, Ginza Branch p. 34
5-7-2 Ginza, San-ai Bldg., 4th and 5th floors
Chuo-ku, Tokyo
Tel.: 03-3289-2311
Hours: 11:00 a.m. to 10:30 p.m. daily

Half Dime, Kawagoe Branch p. 38
5-3 Wakitashinden (Located inside Sanrio Farm)
Kawagoe-shi, Saitama Prefecture
Tel.: 0492-42-3581
Hours: 11:00 a.m. to 2:00 a.m. daily
Lunch: 11:00 a.m. to 5:00 p.m.
(except Sundays and holidays)

Latin, Ginza Branch p. 42
Ginza 4-chome, Kintetsu Bldg., basement second level
Chuo-ku, Tokyo.
Tel.: 03-3564-0485
Hours: 8:00 a.m. to 10:30 p.m.
Mondays through Saturdays
10:30 a.m. to 10:30 p.m.
Sundays and holidays

Ma Maison, Ome Branch p. 46
4-21-4 Shin-machi, Ome-shi, Tokyo
Tel.: 0428-31-8877
Hours: 11:00 a.m. to 11:00 p.m. daily

Sapporo Lion,
The Lion Ginza 7-chome Branch p. 50
7-9-20 Ginza, Ginza Lion Bldg., 1st Floor
Chuo-ku, Tokyo
Tel.: 03-3571-2590
Hours: 11:30 a.m. to 11:00 p.m.
 Monday through Saturdays
 11:30 a.m. to 10:30 p.m.
 Sundays and holidays

Hobson's, Roppongi Branch p. 54
7-8-7 Roppongi, 2 Matsuda Bldg. II, 1st Floor
Minato-ku, Tokyo
Tel.: 03-3479-4610
Hours: Noon to 1:00 a.m. daily

Peltier Harajuku (Chief Branch) p. 58
6-2-9 Jingumae, Shibuya-ku, Tokyo
Tel. 03-3499-4791
Hours: 11:00 a.m. to 9:00 p.m. daily
(Last orders taken at 8:30 p.m.)

Bronze Parrot, Tachikawa Hinobashi p. 62
5-19-14 Nishiki-cho, Tachikawa-shi, Tokyo
Tel.: 042-527-0310
Hours: 11:00 a.m. to 2:00 a.m. daily

Victoria Station, Waseda Branch p. 66
*Sadly, all of the Victoria Station branches closed after
 conducting research for this book.

Kissakan Eikokuya p. 70
3-7-16 Ginza, Chuo-ku, Tokyo
Tel.: 03-3264-0462
Hours: 8:00 a.m. to 10:30 p.m.
 Mondays through Saturdays
 8:00 a.m. to 11:00 p.m. Fridays
 8:00 a.m. to 10:00 p.m.
 Sundays and holidays

Bashamichi, Kashiwa Toyoshiki Branch p. 88
1462-3 Shikoda, Kashiwa-shi, Chiba Prefecture
Tel.: 0471-40-1601
Hours: 11:00 a.m. to 2:00 a.m. daily
(Last orders taken at 1:30 a.m.)

References

Fukushoku zukan ("Illustrated Fashion Guide")
Bunka Publishing Bureau

Fashion Drawing
by Itsuko Aoki
Graphic-sha Publishing Co., Ltd.

Sekai no matsuri & isho
("Festivals and Costumes of the World")
by Hideo Haga
Graphic-sha Publishing Co., Ltd.

Seven Uniform Collection 2000
Hakuyo-sha

Uniform Walker Vol. 1 1999
Kadokawa Shoten Publishing Co., Ltd.

Uniform Walker Vol. 2 2000
Kadokawa Shoten Publishing Co., Ltd.

Kitsuke Lesson ("Lessons in Wearing Kimono")
by Shoichi Amino
Graph-sha, Ltd.

Kantan kitsuke to obimusubi
 ("Wearing Kimono and Tying *Obi* at a Glance")
Shufunotomo Co., Ltd.

Bon 2000 Spring-Summer Uniform Collection
Sanko Hakui K.K.